759.06

759.042 WIL

Simon Wilson

SURREALIST PAINTING

Phaidon

The author and publishers would like to thank all those museum authorities and private individuals who have kindly allowed works in their possession to be reproduced. Plate 23 is reproduced by kind permission of the Paul Nash Trustees. The Solomon R. Guggenheim Museum provided the photograph for Plate 4 and the Pierre Matisse Gallery that for Plate 42. The following plates: 1, 2, 3, 4, 33, 34, 35, 36, 37, 38 are © 1975 SPADEM Paris and 5, 6, 7, 8, 9, 12, 21, 28, 29, 30, 31, 32, 39, 40, 41, 42, 43, 44, 45, 46, 47, 48, are © 1975 ADAGP Paris.

Phaidon Press Limited, 5 Cromwell Place, London SW7 2JL

First published 1975

© 1975 by Phaidon Press Limited

ISBN 0 7148 1693 0

Filmset by Typesetting Services Ltd, Glasgow
Printed in Italy by Amilcare Pizzi SpA

SURREALISM WAS A MOVEMENT in modern art born in 1924 out of the ashes of Dada. It was essentially a continuation of Dada, many of the Dadaists becoming members of the Surrealist group when it formed in Paris in October 1924. The official existence of the group was proclaimed by the publication of the *Manifesto of Surrealism* written by André Breton, Surrealism's founder, its leader and until his death in 1967 the guardian of its doctrinal purity.

Dada and Surrealism were both the result of a far-reaching and widespread revolt by artists of all kinds against the condition of western society as it was at the start of the twentieth century. This revolt was given a focus by the advent of the First World War (Dada began in Zurich in 1916). A civilization that could perpetrate an atrocity on such a scale appeared totally discredited in the eyes of men of sensibility, as were the optimistic rationalist and materialist philosophies on which it was based.

In the *Manifesto of Surrealism* André Breton wrote 'We are still living under the rule of logic . . . The absolute rationalism which remains in fashion allows the consideration of facts relating only narrowly to our experience . . . Under the banner of civilization, under the pretext of progress we have managed to banish from the mind anything which could be accused, rightly or wrongly, of being superstition or fantasy, and to banish also any method of seeking the truth which does not conform to tradition'. The alternative he proposed was the exploration of the irrational part of the human mind, the unconscious: 'If the depths of the mind contain strange forces capable of reinforcing or combating those on the surface it is in our greatest interest to capture them'.

What this meant in the context of art generally was made clear by Breton in his now famous definition of Surrealism: 'SURREALISM, *n.m.* Pure psychic automatism by which it is proposed to express either verbally, or in writing or in any other way, the real function of thought. *Thought's dictation in the absence of all control exercised by reason and outside all aesthetic or moral preoccupation'* (present author's italics). Somehow the artist had to find a way of recording without interference, i.e. 'automatically', the pattern of thought, the flow of impulses from the subconscious mind, and the result would stand as art.

In fact, Breton himself, in collaboration with the writer Philippe Soupault in 1920, had been a pioneer of the crucial technique of automatic writing which he described in the Manifesto, 'Entirely preoccupied as I then still was with Freud and being conversant with his methods of examination which I had had some opportunity to practise myself during the war I resolved to obtain from myself what one tried to obtain from a patient, that is a monologue uttered as rapidly as possible on which no judgement is passed by the subject's critical faculties, which, therefore, is entirely without reticence and which is as nearly as possible *spoken thought'*. Breton is describing the psycho-analytic technique of free association, which was then to be recorded in writing. A text obtained in this way, titled 'Soluble Fish' was published by Breton as an accompaniment to the 1924 Manifesto. These are its opening lines 'At that time of day the park spread its pale hands above the magic fountain. A castle without meaning travelled over the earth's surface. Near to God the castle's notebook lay open at a drawing of shadows, feathers and of irises, "At the Kiss of the Young Widow", it was the

name of the inn caressed by the speed of the automobile and by plants suspended horizontally'. The value of automatic writing lies in the images which are brought together in bizarre and fantastic relationships thus creating a poetry of irrational juxtapositions. This poetic effect Breton referred to as 'convulsive beauty' and it is the basis of Surrealist aesthetics. 'Beauty will be CONVULSIVE or it will not be', he declared in his book *Nadja* (1928); in his later essay 'Beauty Will be Convulsive' he wrote 'In my opinion there can be no beauty—convulsive beauty—except through the affirmation of the reciprocal relationship that joins an object in movement to the same object in repose. I am sorry not to be able to reproduce here the photograph of an express locomotive after having been abandoned for many years to the fever of a virgin forest.' This extraordinary image of a locomotive abandoned in the jungle, frozen in its tracks by vegetation, became famous as an example of convulsive beauty and in 1939 René Magritte painted one of his most memorable pictures, *Time Transfixed* (Plate 9), which clearly refers to it. In another book, *L'Amour Fou,* Breton also made it clear that convulsive beauty was for him, in some sense, erotic.

Automatism proved a highly successful technique in graphic art (automatic drawing, collage techniques) and sculpture (assemblage, use of found objects), but the great classic medium itself, paint on canvas, presented special difficulties. For one thing it seemed to be hopelessly compromised as a traditional and bourgeois art form (Breton once referred to it as 'that lamentable expedient') and for another it seemed impossible to produce automatic painting in the same way as automatic writing or drawing. At the time of the Manifesto Breton was clearly not really concerned with painting. It is barely mentioned in the Manifesto as a whole, and is conspicuously absent from the famous definition. Not long after the Manifesto was published Pierre Naville wrote (in the group's magazine 'Surrealist Revolution') 'Everyone knows that there is no *Surrealist painting*'. This was in April 1925 and the first exhibition of Surrealist painters took place only six months later. Moreover when Breton wrote the Manifesto he almost certainly owned Max Ernst's painting *Men Shall Know Nothing of This* (Plate 2) done in 1923. We now see this and one or two other works by Ernst of the early 1920s such as *The Elephant Celebes* (Plate 1) of 1921 and *Oedipus Rex* of 1922, both of which belonged to Ernst's Surrealist friend Paul Eluard, as the first masterpieces of Surrealist painting. But Breton and the literary Surrealists were so obsessed with the idea of automatism that they failed to recognize the deliberately wrought paintings of Ernst as Surrealist. Ernst had in fact succeeded in producing paintings which were a visual equivalent of the convulsive poetry of automatic writing: bizarre but precise images in strange juxtapositions.

The origins of this new kind of painting lie in Ernst's discovery in 1919 of the work of the Italian metaphysical painter Giorgio de Chirico and his subsequent development first of the important Surrealist technique of collage and then of a fully fledged Surrealist painting. Collage, Ernst has stated in the catalogue of his exhibition at Cologne and Zurich 1962–3, 'is the systematic exploitation of the fortuitous or engineered encounter of two or more intrinsically incompatible realities on a surface which is manifestly inappropriate for the purpose and the spark of poetry which leaps across the gap as these two realities are brought together' (cited by Schneede in *The Essential Max Ernst*, London 1972). The collages, it is worth noting, were the most significant contribution thus far made to Surrealism in the visual arts as Breton himself admitted in a retrospective look

at the development of Surrealism published in 1941, *Genèse et Perspective Artistiques du Surréalisme*: '. . . we can easily see now that Surrealism was already in full force in the work of Max Ernst. Indeed, Surrealism at once found itself in his 1920 collages'. The conception of collage was carried over into Ernst's paintings of 1921–4; *The Elephant Celebes, Oedipus Rex, Men Shall Know Nothing of This* are, in a sense then, painted collages but with the important differences that their imagery is unified and monumental, that they employ illusionistic form and space, that they are much larger in scale, and that they often refer to the dream. In the winter of 1922–3 André Breton and the group around him including Max Ernst devoted themselves to a deliberate cultivation of the dream state, meeting each evening in a darkened room and creating a state of collective trance in which each, as the inspiration took him, delivered to the group an untrammelled flow of words. This period became known as the 'Saison des Sommeils' (the season of sleeps). Breton explicitly acknowledges in the Manifesto the Surrealists' debt to Freud both for his investigation of the dream and for his general theory of the unconscious. More specifically, Freud's theory of the dominance of the unconscious by the twin instincts of sexuality and death ('The aim of all life is death', he stated in *Beyond the Pleasure Principle* of 1921) provided an endorsement for the Surrealists' predilection for erotic and macabre subject matter, particularly in combination. These paintings by Ernst and the early work of de Chirico became the models and point of departure for a whole group of Surrealist painters, Magritte, Delvaux, Dali among them.

But the problem still remained of how to execute a painting automatically and it is one of the most astonishing facts in the history of Surrealism that Max Ernst, having created one kind of Surrealist painting then almost immediately invented another, which was, furthermore, an automatic one. It is for this reason that he has become known as 'the compleat Surrealist'. This new kind of painting was based on the technique of frottage which Ernst discovered in 1925. Essentially, this consisted of taking rubbings in pencil from surfaces or objects whose texture or form obsessed him. The technique, although originally a graphic one, was quickly adapted to painting, Ernst either scraping the paint onto a canvas placed over the textured surface or object or, in some cases, coating the object itself with paint and imprinting it onto the canvas. As Ernst himself has written in his autobiographical fragment 'An Informal Life of M.E.' (Museum of Modern Art, Catalogue of 1961) '. . . by excluding all conscious mental influences (of reason, taste or morals) and by reducing to a minimum the active part of what until now has been called the "author", *this process revealed itself as the exact equivalent of what was known as automatic writing*' (present author's italics). The first great frottage paintings were the *Forests* (Plate 38) which Ernst began in 1925.

About this time, two other painters, Joan Miró and André Masson, were independently developing their own kinds of automatic painting. 'The tumultuous entry of Miró, in 1924, marked an important stage in the development of Surrealist art', wrote André Breton in *Genèse et Perspective du Surréalisme*; it was in that year that Joan Miró began a series of automatic paintings, which continued until 1927. About one hundred and fifteen of these paintings are extant; and among them is perhaps his greatest masterpiece *The Birth of the World* (Plate 40). In these works Miró carried over the free flowing calligraphy of automatic drawing and he also developed various spontaneous and improvisatory ways of applying paint, wiping it rapidly onto the canvas and even, as in *The Birth of the World*, for

example, flooding it on so that it dripped and ran down the surface. He also produced astounding new images, mysterious forms relating to the basic processes of life—especially procreation—to the cosmos and to the archetypal world. These images are called 'biomorphic'. It is clear that during this period Miró had great freedom of access to his unconscious and in an interview in 1946 he explained 'in 1925 I was drawing almost entirely from hallucinations. At the time I was living on a few dried figs a day. Hunger was a great source of these hallucinations. I would sit for long periods looking at the bare walls of my studio trying to capture these shapes on paper or canvas.'

André Masson met André Breton early in 1924 and became an official member of the Surrealist group when it formed in October, signing the Manifesto and contributing to the first issue of 'The Surrealist Revolution' a drawing which, while still revealing the influence of Cubism, was unusually free and spontaneous in execution. By the time the next issue appeared on 15 January 1925 he was able to contribute a drawing that was both fully automatic in execution and strongly erotic in feeling. Masson quickly became the best known practitioner of automatic drawing but it was not until 1927 that he succeeded in applying the process to painting. This is his description of what happened: 'It was at the beginning of 1927, I was living by the sea and one day I wondered why I shouldn't use *sand* in an automatic way. I had noticed that my first automatic drawings were born from a method, I knew what I had to do: empty oneself, make oneself completely available without any premeditation. Ink and white paper, usually in very large sheets, enabled me to make a drawing in a few seconds. I did not think about what I was doing. Only afterwards did I see that there were signs that could be interpreted. But in oil painting an element of resistance, stemming from the canvas and the preparation of the colours prevented any automatism. I had to find a way. That way was Sand.

I began by laying flat a piece of canvas on a stretcher covered with raw canvas. On it I then threw pools of glue that I manipulated. Then I scattered sand, then shook the picture to produce splashes and pools, sometimes I scraped it with a knife. I obtained something which had no meaning but which could stimulate meaning. And all this done at express speed. I took different grades of sand building up successive layers with more glue, in the end it became a sort of wall, a very uneven wall, and then at particular moments the layers would suggest forms although almost always irrational ones. With a little thinned paint I added a few lines, but as rapidly as possible and then, already calming down a bit, a few touches of colour. Nearly always the sky was indicated at the top with a little patch of blue and at the bottom there would always be a pool of blood, I have no idea why.' (Quoted by Clébert in *Mythologie d'André Masson,* Geneva, 1971. Present writer's translation). Masson eventually produced a group of about twenty of these paintings, among them the great *Battle of Fishes* (Plate 44) now in the Museum of Modern Art in New York.

Thus, by 1927, two distinct kinds of Surrealist painting had been evolved.

Plate 1. MAX ERNST (b. 1891): *The Elephant Celebes.* 1921. Canvas 125 × 107 cm. (49¼ × 42⅛ in.) London, Private Collection.
The artist has revealed to Roland Penrose that the title of the painting has its origin in a scatological rhyme popular among German schoolboys in his youth. *The Elephant Celebes* displays a characteristic Surrealist blend of the macabre and

the erotic with its naked headless woman and the multiplicity of phallic symbols—horns, tusks, spouts and the trunk-like organ which extends or is in the process of extending from the interior of the monster. This fearsome horn tipped instrument of rape appears to be responding to the beckoning hand of the naked woman. A deep pessimism, engendered by the First World War, is expressed in Ernst's art of this period. He had served four years in the German army before being invalided out in 1917 and later wrote 'How to overcome the disgust and fatal boredom that military life and the horrors of war create? Howl? Blaspheme? Vomit?' It seems possible that the monster Celebes is a reference to the tanks which the British first used on the Somme in 1916 and which apparently devastated the morale of the German troops until they got used to them. Penrose has suggested that the image of the headless woman is associated by Ernst with the traumatic death in 1897 of his elder sister.

Plate 2. MAX ERNST: *Men Shall Know Nothing of This*. 1923. Canvas 80 × 64 cm. (31⅝ × 25⅛ in.) London, Tate Gallery.

This is perhaps the most fully elaborated of Ernst's early Surrealist paintings. It has all the qualities which were to become the basis of the figurative-illusionist art of René Magritte, Pierre Roy, Paul Delvaux, Salvador Dali and many others; its subject matter is sexual, the central image being a copulating couple suspended in space. The hand hiding the planet below the figures (the earth) echoes the modest gesture of the classical *Venus Pudica* (Modest Venus) and the planet is also therefore a symbol of the female sex. The two cones of shadow rising from the base of the picture, each topped with a planet, are clearly phallic as is probably also the small object suspended from the crescent moon which the artist says is a 'little whistle'. There is a strong feeling of death produced by the dismembered hand, the missing upper parts of the couple and the heap of viscera in the foreground. The setting is sterile interplanetary space and the subjects are suspended in what seems to be an infinite void. The atmosphere is dream-like. The images are individually recognizable, even familiar, but are brought together in bizarre juxtapositions (convulsive poetry). The painting is executed in the rather neutral, deadpan, figurative manner of certain nineteenth century narrative and genre paintings so that emphasis is on the imagery of the work rather than the way it is rendered as it was in most modern art before Surrealism. This manner of painting was also probably a conscious denial of traditional aesthetic 'painterly' values. The mysterious, enigmatic, ultimately inexplicable nature of the painting is pointed up by its title, in other words, no explanations are possible.

Plate 3. MAX ERNST: *The Equivocal Woman* (also known as *The Teetering Woman*). 1923. Canvas, 130 × 97 cm. (51¾ × 38⅛ in.) Düsseldorf, Schloss Jägerhof.

Fantastic machinery is common in Dada and early Surrealist art and Ernst produced many weird and wonderful inventions in his collages from 1918 onwards. In this painting there seems to be a science fiction sex machine and the suggestion, as so often in Surrealist art, of an extra-terrestrial setting.

Plate 4. MAX ERNST: *The Robing of the Bride*. 1939. Canvas, 130 × 96 cm. (51¼ × 37⅜ in.) Venice, Peggy Guggenheim Foundation.

In this painting Ernst returned to the illusionist-figurative technique of his early work to create a great masterpiece of erotic fantasy. In the court of some archaic

king, a virgin bride is being prepared for what promises to be a savage defloration; she is already being directly threatened by the phallic arrow of the grotesque birdman. Her hand is both hiding and protecting the area of her sex in the classic gesture of the *Modest Venus*. But the effect of this gesture is far from modest since together with the arrow it draws attention to the sexual zone which becomes in fact the focal point of the picture. In spite of this emphasis the painting is dominated by the amazing feathered cloak, which appears to be made from the entire flayed skin of a gigantic owl (a bird associated with magic and witchcraft), whose texture and indescribable colour contribute largely to the erotic atmosphere of the painting. This cloak reveals again Ernst's obsession with birds and although the head is clearly an owl's, it brings to mind, especially in its colour, the reference in Ernst's autobiography to the traumatic death of his pet pink cockatoo in 1906. The critic Robert Melville has also suggested that the cloak may have been inspired by a Peruvian mantle of feathers owned by Ernst. These cloaks were apparently used in the sadistic and macabre ritual of Inca human sacrifice and Ernst's painting has itself precisely an atmosphere of primitive ritual.

Plate 5. RENÉ MAGRITTE (1898–1967) : *The Reckless Sleeper.* 1927. Canvas, 115 × 82 cm. (45½ × 32 in.) London, Tate Gallery.
One of many Surrealist paintings which contain sleeping figures and which specifically refer to the dream. The title perhaps implies that it is a reckless act we perform every night when we surrender ourselves to the mysterious alternative world of the dream.

Plate 6. RENÉ MAGRITTE: *Pleasure.* 1926–7. Canvas, 74 × 98 cm. (29⅛ × 38⅝ in.) Düsseldorf, Schloss Jägerhof.
Werner Schmalenbach, director of the Nordrhein-Westfalen collection, has pointed out that Magritte is here creating his own version of the Garden of Eden myth. Eve becomes a vampiric young girl, the apple becomes a live bird. The title *Pleasure* as well as the girl's expression, her eyelids drooping, make it clear that Magritte's interpretation of the Christian myth is a sexual one and furthermore macabre and perverse in the extreme. Many of the Surrealists were fascinated by the sexuality of young girls and by the notion of corrupted innocence. As well as being an image of sadistic sexuality this painting is a powerful symbolic representation of the loss of virginity in which the artist makes particularly telling use of the splashes of the bird's blood on the pure white of the girl's lace collar.

Plate 7. RENÉ MAGRITTE: *The Threatened Assassin.* 1926–7. Canvas, 155 × 195 cm. (59¼ × 77 in.) New York, Museum of Modern Art.
This painting, like *Pleasure,* is one of Magritte's earliest masterpieces, being included in his first one man exhibition at the Galerie Le Centaure in Brussels in 1927. It also combines the themes of sexuality and death in a macabre and perverse way: a sex murderer, hand casually in pocket, calmly listens to a record while his naked victim bleeds to death behind him. He is apparently oblivious both to the two bowler hatted detectives, bizarrely armed with a club and a net, who await him just beyond the confines of the room and to the three more detectives peering over the balcony rail outside the window. Criminals were of great interest to the Surrealists and at the time Magritte painted this picture the

popular thriller series Fantomas was something of a cult among them. In Fantomas the master criminal hero is constantly escaping from seemingly foolproof traps set for him by his adversary Inspector Juve of the Sûreté.

Plate 8. RENÉ MAGRITTE: *The Red Model.* 1934. Canvas, 73 × 48 cm. (28¾ × 19⅛ in.) Sussex, Edward James Foundation.

One of the paintings in which Magritte combines objects in such a way as to produce an 'impossible' new object which because it is painted in a conventional representational way is nevertheless there, existing before the spectators' eyes. The effect of such an image is to produce an intense sense of shock, bafflement and frustration: however hard you look the object refuses to resolve itself entirely into its components—boot and foot in this case—although both are clearly there. The title merely adds to the enigma since it appears to be totally unrelated to the imagery of the picture.

Plate 9. RENÉ MAGRITTE: *Time Transfixed.* 1939. Canvas, 146 × 97 cm. (57½ × 38⅜ in.) Chicago, Art Institute.

According to Suzi Gablick (*Magritte,* London 1970) this memorable painting was born from a sudden vision, without the long period of reflective examination usual with Magritte. This picture precisely expresses the notion of the moment of cessation of movement—the moment, in fact, at which time is transfixed.

Plate 10. PIERRE ROY (1880–1950): *Danger on the Stairs.* 1927–8. Canvas, 91 × 60 cm. (36 × 23⅝ in.) New York, Museum of Modern Art.

The scene depicted here is basically banal: the stairway of a typical French apartment building. But it is painted in such a way as to produce a strongly dream-like atmosphere; there is a mystery about the closed doors as well as about the extensions of the staircase beyond the confines of the picture and the disruption of everyday reality is completed by the introduction of the snake. The painting also has that quality of unnatural stillness, of frozen time, demanded by André Breton.

Plate 11. PIERRE ROY: *A Naturalist's Study.* 1928. Canvas, 92 × 65 cm. (36¼ × 25⅝ in.) London, Tate Gallery.

Pierre Roy was in the grip of a deep depression at the time he painted this picture; indeed everything in it seems emblematic of frustration and impotence. The eggs are blown, the writing in the notice is unreadable, the train has stopped (the steam from the whistle and the smoke from the stack go in opposite directions), the wheel is made useless by its blocked hub and the phallic symbol of the snake, alive and real in *Danger on the Stairs,* is here merely paper, pinned helplessly to the floor.

Plate 12. MAN RAY (b. 1890): *Pisces.* 1938. Canvas, 65 × 73 cm. (25⅝ × 28¾ in.) London, Tate Gallery.

The woman is asleep and seems to be dreaming of the fish, a very obvious phallic symbol. The fish is shown swimming through a tunnel-like space and the woman would appear therefore to be dreaming of the phallus and also of being penetrated by it. But Man Ray has gone beyond the simple depiction of a sexual dream in terms of Freudian symbolism by painting the woman so that she

9

resembles the fish—her feet are like its tail, her breast is like its eye, her whole shape is elongated and streamlined; her obsession with the fish/phallus is so strong that she is becoming one herself. The Surrealists were fascinated by the process of metamorphosis.

Plate 13. PAUL DELVAUX (b. 1897): *The Call of the Night*. 1937. Canvas, 113 × 133 cm. (44½ × 52¼ in.) London, Private Collection.
In a barren landscape, the site of ancient cults, emblems of death and life are revealed by the dawn light. This beautiful picture, one of the most authentically poetic and mysterious of Delvaux's works, is perhaps his greatest masterpiece. Strangely, it is not included in the standard oeuvre catalogue.

Plate 14. PAUL DELVAUX: *The Public Voice*. 1948. Canvas, 152 × 254 cm. (60 × 100 in.) Brussels, Musées Royaux.
The nude girl and her three enigmatic attendants seem quite unconcerned at their somewhat unusual situation. Beyond them we glimpse the streets of the mysterious city that provides a setting for so many of Delvaux's paintings and which he named, in the title of a work of 1941 'La Ville Inquiète' (the uneasy city).

Plate 15. PAUL DELVAUX: *The Night Train*. 1947. Canvas, 153 × 210 cm. (60¼ × 82¾ in.) Tokyo, Ginza Nova.
On the subject of railway stations, Delvaux has said 'And then there is the nostalgia of waiting rooms where people go past, departing, running away, leaving their own homes: the sad, abandoned, mournful feeling they have with their worn, threadbare, dusty and smoke laden curtains and the barmaid behind her black counter with its bottles.' He might have added that because they are places of transit, in which the normal realities of daily life are suspended, they are particularly suitable as a setting for erotic fantasies.

Plate 16. PAUL DELVAUX: *Venus Asleep*. 1944. Canvas, 173 × 200 cm. (68 × 78¾ in.) London, Tate Gallery.
This is a perfect Freudian dream painting in that it depicts, more explicitly than perhaps any other Surrealist painting, the duality of, and association between, Eros and Thanatos. Venus, one of Delvaux's characteristic, calmly erotic nudes, sleeps on a gorgeous gold and purple couch. If we read the picture as her dream then she is dreaming of death and while she does so one leg slips from the couch putting her in a position to receive the embrace of death who approaches from the couch's foot.
Delvaux painted this picture in Brussels in 1944 during the German flying bomb attacks on the city. In a letter of 31 May, 1957, he wrote '. . . the psychology of that moment was very exceptional, full of drama and anguish. I wanted to express this anguish in the picture contrasted with the calm of Venus'. He also wrote 'It is my belief that, perhaps unconsciously, I have put into the subject of this picture a certain mysterious and intangible disquiet'. He has indeed.

Plate 17. BALTHUS (b. 1908): *Sleeping Girl*. 1943. Panel, 80 × 98 cm. (31⅜ × 38¾ in.) London, Tate Gallery.
Balthus was not strictly speaking a Surrealist but he had friends among them and his work held a powerful appeal for the Surrealist sensibility. This appeal

Plate 23. PAUL NASH: (1889–1946): *Landscape from a Dream.* 1936–8. Canvas, 68 × 102 cm. (26¾ × 40 in.) London, Tate Gallery.

Paul Nash was an English visionary landscape painter who was strongly influenced by Surrealism in the 1930s. The setting of this dream is the Downs above Swanage in Dorset. In the centre of the picture is a large mirror. Beyond the mirror the sky is a serene blue but the reflected sky is shot with red and the horizon filled by a huge blood-red sun. A hawk wheels in the sky and another hawk stands before the mirror, its reflected face looking out at the spectator. There is an atmosphere of menace which may be an expression of the artist's awareness of the approach of war.

Plate 24. ROLAND PENROSE (b. 1900): *Portrait of Valentine.* 1937. Canvas, 60 × 44 cm. (23½ × 17¼ in.) London, Private Collection.

This portrait is given a particular intensity by the poetic fantasy of the butterflies clinging to her eyes and mouth, the rose around her neck and the birds nestling in her hair. These are all delicately worked in beautiful colours, the paint scraped on with a knife, so that the butterflies and the rose flower in particular take on a jewel-like quality, appearing to be encrusted upon the extraordinary blue flesh.

Plate 25. THOMAS LOWINSKY (1892-1947): *The Dawn of Venus.* 1922. Canvas, 77 × 73 cm. (30½ × 28⅝ in.) London, Tate Gallery.

In this exquisitely painted picture, Venus sleeps in her clam shell on the sea bed. Her lips are curved in a secret archaic smile: she is dreaming her last dream of the night while in the world above dawn breaks, shedding an unearthly light over the fantastic submarine landscape.

Plate 26. JOHN ARMSTRONG (1893–1973): *Dreaming Head.* 1938. Canvas, 46 × 78 cm. (18¼ × 30¾ in.) London, Tate Gallery.

This beautiful painting reveals the characteristic Surrealist preoccupation with dreams and especially with dreaming women. Armstrong has written that in his pictures 'women and flowers express states of love' and here the convolvulus flowers sprouting from the base of the girl's head seem to be a marvellously poetic symbol of rebirth and growth.

Plate 27. DOROTHEA TANNING (b. 1910): *Eine Kleine Nachtmusik.* 1946. Canvas, 41 × 61 cm. (16 × 24 in.) London, Private Collection.

Dorothea Tanning deploys a peculiarly feminine erotic sensibility in her depiction of this bizarre encounter between a giant sunflower equipped with phallic tentacles and two little girls who seem both innocent and depraved.

Plate 28. SALVADOR DALI (b. 1904): *The Persistence of Memory.* 1931. Canvas, 25 × 36 cm. (10 × 14 in.) New York, Museum of Modern Art.

This is one of his first paintings, and remains perhaps the most memorable, in which Dali depicts normally hard or firm objects as limp, soft, melting, flowing. In his book *Conquest of the Irrational* Dali wrote 'be persuaded that Dali's famous limp watches are nothing else than the tender extravagant and solitary paranoiac-critical camembert of time and space.'

lay in the way in which Balthus renders an observed reality in a rich and sensuous technique, yet at the same time manages to create a strong atmosphere of disturbance, mystery and oppression.

Plate 18. PAUL DELVAUX: *Les Belles de Nuit.* 1936. Canvas, 91 × 91 cm. (36 × 36 in.) Sussex, E. F. W. James, Esq.
Delvaux here evokes a mood of disquiet by contrasting the lush bodies of the women with the mysterious building, the sterile landscape and especially with the two skulls, emblems and reminders of death.

Plate 19. BALTHUS (b. 1908): *Girl and Cat.* 1937. Panel, 87 × 78 cm. (34½ × 30¾ in.) Chicago, Mr and Mrs E. A. Bergman.
In this painting the source of the disturbance is clearly the eroticism of the young girl's pose but the painter has also given her something of the sphinx-like cat's calm, mysterious, withdrawn quality.

Plate 20. CONROY MADDOX (b. 1912): *Passage de l'Opéra.* 1940. Canvas, 136 × 94 cm. (53¾ × 37 in.) London, Hamet Fine Art.
The Passage de l'Opéra was one of the old Paris arcades most of which have now disappeared. It was made famous by the Surrealist poet Louis Aragon who described it in his book *Le Paysan de Paris* of 1924. Conroy Maddox writes of his painting that it was certainly inspired by this book. 'Aragon points out that his wanderings around the Passage de l'Opéra were without purpose, yet he waited for something to happen, something strange or abnormal so as to permit him a glimpse of a "new order of things" . . . The picture was not painted until I returned to England, then entirely from memory. Certainly over a year after I had seen either the place or a photograph. It was not until the Cardinal and Short book *Surrealism, Permanent Revelation* was published in 1970 that I again saw a photograph of the passage and was able to check the accuracy of my memory. Apart from some architectural discrepancies, the lion in the foreground was certainly not present and obviously never had been in spite of my conviction that such a statue had existed near the entrance.'
The sense of frozen time and the mystery of the figures themselves, especially the faceless one in the foreground, banal but sinister in his bowler hat, all combine to convey the feeling that something abnormal is about to happen.
This painting remains one of the monuments of British Surrealist art.

Plate 21. LEONOR FINI (b. 1908): *Figures on a Terrace.* 1938. Canvas, 99 × 78 cm. (39 × 31 in.) Sussex, Edward James Foundation.
This painting appears to depict the aftermath of an orgy on the terrace of some mysterious palace or château.

Plate 22. THOMAS LOWINSKY (1892–1947): *The Breeze at Morn.* 1930. Canvas, 44 × 91 cm. (17⅜ × 36 in.) London, Tate Gallery.
Thomas Lowinsky extended into the twentieth century the British imaginative tradition of William Blake and the Pre-Raphaelites and in his work from about 1920 onwards he seems to have been working along the same lines as, or even to have been a precursor of, the Surrealists. Paintings such as *The Breeze at Morn* have an intensely dream-like quality which verges on the hallucinatory.

Plate 29. SALVADOR DALI: *Sleep*. 1937. Canvas, 51 × 78 cm. (20 × 30¾ in.) USA, New Trebizond Foundation.

This is Dali's own unique image of the dream state of which he wrote: 'Sleep is a state of equilibrium, a kind of monster in which your body disappears. Nothing is left then but the head supported by a subtle host of crutches; should one crutch move, then the sleeper awakens. It is only when all the crutches are balanced, and this is seldom possible, that the god of sleep can take possession of you.'

Plate 30. SALVADOR DALI: *Soft Construction with Boiled Beans: Premonition of Civil War*. 1936. Canvas, 97 × 99 cm (38⅜ × 39 in.) Philadelphia, Museum of Art. Louise & Walter Arensberg Collection.

This is one of the most powerful evocations of the horror of war since Dali's fellow countryman Goya's series of etchings 'The Disasters of War', of 1810–13 to which this painting owes a good deal.

Plate 31. SALVADOR DALI: *Autumn Cannibalism*. 1936. Canvas, 63 × 63 cm. (25 × 25 in.) Sussex, Edward James Foundation.

Painted just after the outbreak of the Spanish Civil War, this is a remarkably original visual metaphor for a nation violently divided against itself and its repulsive savagery well reflects the nature of the conflict that was developing when Dali painted it.

Plate 32. SALVADOR DALI: *The Metamorphosis of Narcissus*. 1934. Canvas, 51 × 78 cm. (20 × 30¾ in.) Sussex, Edward James Foundation.

Shortly after completing this painting Dali published a book with the same title containing a long poem, a brief account of the inspiration of the painting and the statement that the poem and the painting together constitute 'the first poem and painting obtained entirely through the integral application of the paranoiac-critical method'. The paranoiac-critical method is Dali's name for his system of elaborating Surrealist imagery in which the artist's mental processes are roughly comparable to those of someone suffering from paranoia. A paranoiac constantly has to reinvent reality to make it correspond to his own delusions. Dali in fact once said that the only difference between him and a madman was that he was not mad and his best paintings seem to be the result of his amazing ability to think like a madman without actually being one. In this painting Narcissus appears three times: first on a pedestal in the background posing, as we would say, narcissistically, then kneeling in the fatal pool in the process of transformation or metamorphosis and then on the bank of the pool, fully transformed into a limestone hand holding an egg from which blooms the full blown flower. The source of inspiration for this extraordinary imagery was a conversation, overheard by Dali between two fishermen at Port-Lligat in Catalonia, Spain, where the artist lives:

First Fisherman: What's wrong with that chap glaring at himself all day in his looking glass?

Second Fisherman: If you really want to know (lowering his voice) he has a bulb in his head.

Dali comments: ' "A bulb in the head" in Catalan corresponds exactly with the psycho-analytic notion of complex. If a man has a bulb in his head it might break into flower at any moment, Narcissus!'

Plate 33. YVES TANGUY (1900–55): *The Ribbon of Extremes.* 1932. Canvas, 35 × 45 cm. (13¾ × 17¾ in.) London, Private Collection.

The foreground of this exquisitely luminous picture is crowded with sharply defined forms, linked together in a fluid way with the suggestion of an orgiastic procession, a kind of bacchanalia of biomorphs (forms arrived at by a process of abstraction from human, animal and vegetable life—and sometimes from landscape as well).

Plate 34. YVES TANGUY: *Mama, Papa is Wounded!* 1927. Canvas, 92 × 73 cm. (36¼ × 28¾ in.) New York, Museum of Modern Art.

This is one of his early biomorphic masterpieces. The small form, like a jumping bean in the centre, is presumably the distressed infant. There is a sense of alarm in this painting which comes partly from the strangeness of the imagery and the landscape but mainly perhaps from the fearsome phallic object on the right.

Plate 35. YVES TANGUY: *Outside.* 1929. Canvas, 118 × 91 cm. (46½ × 36 in.) London, Private Collection.

Tanguy developed very rapidly as a painter in the late 1920s and *Outside* is one of the first great works of his full maturity.

Plate 36. MAX ERNST: *The Whole City.* 1935. Canvas, 60 × 81 cm. (23⅝ × 31⅞ in.) Zurich, Kunsthaus.

Here Ernst has used the frottage method to create an image which suggests the crumbling ruins of some long dead, unimaginably archaic city. Its other worldliness is emphasized by the huge alien sun and it is one of Ernst's most haunting and enigmatic works.

Plate 37. MAX ERNST: *Europe after the Rain.* 1940–2. Canvas, 55 × 148 cm. (21½ × 58⅛ in.) Hartford, Conn., Wadsworth Atheneum.

After the outbreak of World War II Ernst was twice interned by the French as an enemy alien. He was eventually released in the early summer of 1940 and began to paint *Europe after the Rain* at his home in Saint Martin d'Ardèche near Avignon. In 1941 he escaped from the Gestapo to the United States where the picture was completed in New York.

This is one of a group of paintings which clearly reflect the artist's wartime experiences in their general pessimism. This one is a fantastic vision of a shattered world with a lone warrior standing beside his crushed warhorse, isolated amidst the ruins. The 'rain' of the title perhaps refers to the rain of bombs that devastated Europe in the latter stages of the war.

The richness, the encrusted mineral quality of this painting comes partly from Ernst's use in its early stages, of the automatic technique of decalcomania, which involves pressing thin paint onto the canvas with a sheet of glass or other smooth surface. The spreading of the paint produces curious textures and configurations, best seen in the rock formations on the left.

Plate 38. MAX ERNST: *The Forest.* 1927. Canvas, 100 × 81 cm. (39½ × 32 in.) London, Tate Gallery.

One of the 'Forest' series of frottage paintings started by Ernst in 1925. The paint has been scraped across the canvas to produce an image powerfully

suggestive of the primeval world: the trees almost seem to be fossilized. Trapped among them is a small bird and the painter has scraped a few lines around it to indicate a cage.

Plate 39. JOAN MIRÓ (b. 1893): *Maternity.* 1924. Canvas, 92 × 73 cm. (36¼ × 28¾ in.) London, Private Collection.
This painting is one of the first in which Miró radically reduced the quantity of imagery and began to float the elements against pure coloured grounds suggestive of deep dreamlike space.

Plate 40. JOAN MIRÓ: *The Birth of the World.* 1925. Canvas, 245 × 195 cm. (96½ × 76¾ in.) New York, Museum of Modern Art.
This is probably Miró's greatest work and one of the very great masterpieces of early twentieth century art. The execution is highly spontaneous, the paint having been allowed to run and drip down the canvas to form configurations determined to some extent by its own physical properties. The birth of the earth and the sun from the primeval cosmic chaos is an entirely valid interpretation but there is no doubt that the imagery refers also to the processes of procreation.

Plate 41. JOAN MIRÓ: *Stars in Snails' Sexes.* 1925. Canvas, 130 × 97 cm. (51¼ × 38⅛ in.) Düsseldorf, Schloss Jägerhof.
One of the most original aspects of Miró's paintings of the 1920s is his inclusion of poetic statements, written with the brush in a free flowing calligraphy that makes them as significant visually as verbally. The title is a literal translation of the words on this canvas and the phrase is a marvellous example of the fantasy of Miró's poetic imagination.

Plate 42. JOAN MIRÓ: *Photo: This is the Colour of My Dreams.* 1925. Canvas, 96 × 130 cm. (38 × 51 in.) New York, Private Collection.
The meaning of the word 'Photo' in this painting remains obscure, possibly it implies that photographs are as unlike reality as the colour Miró can reproduce is unlike his dream. But the association of the colour blue with dreams is clear enough and sheds an interesting light on Miró's extensive use of blue in his paintings of this period.

Plate 43. JOAN MIRÓ: *Painting.* 1927. Canvas, 97 × 130 cm. (38¼ × 51¼ in.) London, Tate Gallery.
This is another of Miró's paintings in which the imagery refers to sexual processes at a very elementary level: at the lower right is a free swimming spermatozoa-like creature.

Plate 44. ANDRÉ MASSON (b. 1896): *Battle of Fishes.* 1927. Canvas, 36 × 73 cm. (14¼ × 28¾ in.) New York, Museum of Modern Art.
The significance of Masson's sand paintings, of which this is one, and his method of making them are described in the Introduction.
Masson has written: 'The fish are anthropomorphic and curiously enough at that time an American writer that I had never heard of, H. P. Lovecraft, had imagined or believed he had seen (because he was undoubtedly a visionary) a human population issue from couplings of women with fish.' This painting seems to be a

15

vision of the archaic primeval marine world where our ancestors fought the evolutionary battle before eventually clambering onto the land.

Plate 45. ROBERTO MATTA (b. 1912): *The Hanged Man*. 1942. Canvas 97 × 130 cm. (38¼ × 51¼ in.) Basel, Galerie Beyeler.

Roberto Matta joined the Surrealist group in Paris in 1937 then emigrated to the USA in 1939. This painting is an early example of his fully mature style in which biomorphic forms hang in a strange labyrinthine space. Matta was deeply interested in magic and allied subjects and the title comes from the tarot card of that name. Sketches in Matta's notebook reveal that the large form on the left of the painting ultimately derives from an image of a foetus in the womb.

Plate 46. ROBERTO MATTA: *The Vertigo of Eros*. 1944. Canvas, 196 × 252 cm. (77 × 99 in.) New York, Museum of Modern Art.

The American art historian William Rubin wrote of this painting that it is 'the most profound of Matta's works and the central image of his oeuvre. This is the cosmic Matta who, in the evocation of infinite space, suggests simultaneously the vastness of the universe and the profound depth of the psyche. The title relates to a passage in Freud in which he locates all consciousness as falling between Eros and the death instinct—the life force and its antithesis. Afloat in a mystical light which emanates from the deepest recesses of space, an inscrutable morphology of shapes suggesting liquid, fire, roots and sexual parts stimulates an awareness of inner consciousness such as we trap occasionally in revery and dreams.'

The title could refer to orgasm, the dizzy moment which the French call 'le petit mort', the little death.

Plate 47. ROBERTO MATTA: *Black Virtue*. 1943. Canvas, 76 × 181 cm. (30⅛ × 71⅛ in.) London, Tate Gallery.

This beautifully painted triptych is one of Matta's masterpieces. In the two wings the space is articulated by mysterious floating planes but in the centre the forms are biomorphic and clearly refer to the female sex organs.

The artist has said that he cannot remember the exact significance of the title but it may even refer to the so-called virtue in wartime of killing the enemy. He and his friends were extremely anti-Nazi at this period. Certainly the large amount of black in this painting gives it a strong feeling of death.

Plate 48. HANS BELLMER (b. 1902): *The Spinning Top*. 1944–9. Canvas, 65 × 65 cm. (25½ × 25½ in.) London, Tate Gallery.

Hans Bellmer is an artist who explores the multitudinous analogies between the various erogeneous zones of the human anatomy and blends them together with other parts of the body into strange new configurations. Here the 'spinning top' is composed of a skeletal hand and arm topped by a formation which can be seen to be composed of breasts, buttocks, a vulva and the head of a phallus. This extraordinary image is made particularly effective by the exquisite precision of Bellmer's draughtsmanship, the delicacy of his execution, and the beautiful silver grey tones of the paint.

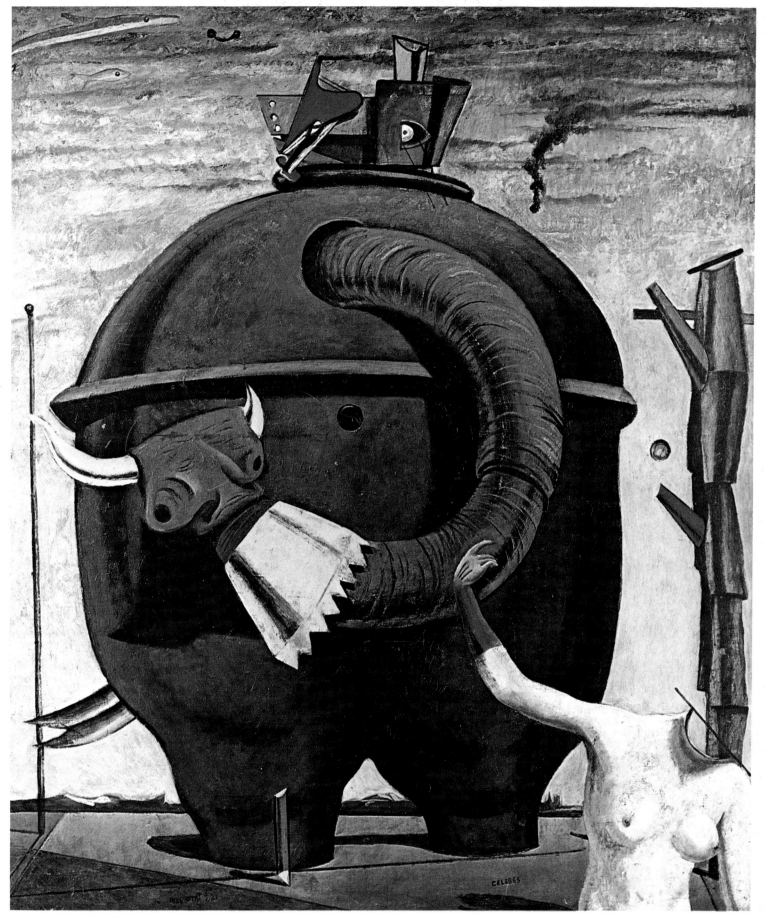

1. Max Ernst (b. 1891): *The Elephant Celebes*. 1921. London, Private Collection

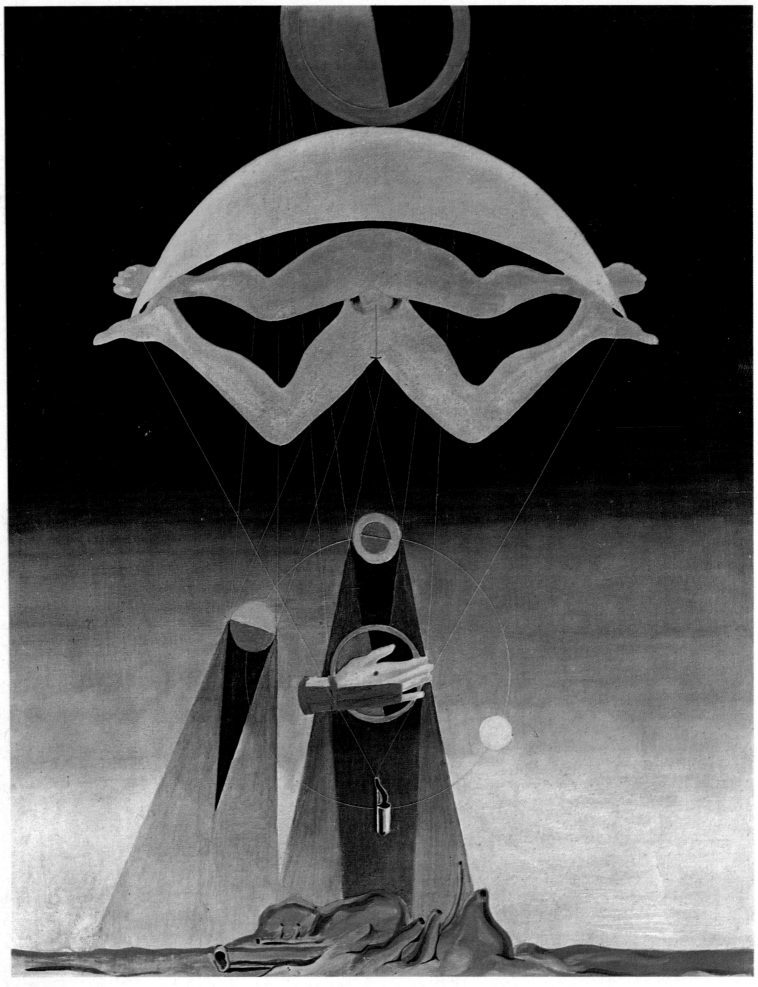

2. Max Ernst (b. 1891): *Men Shall Know Nothing of This*. 1923. London, Tate Gallery

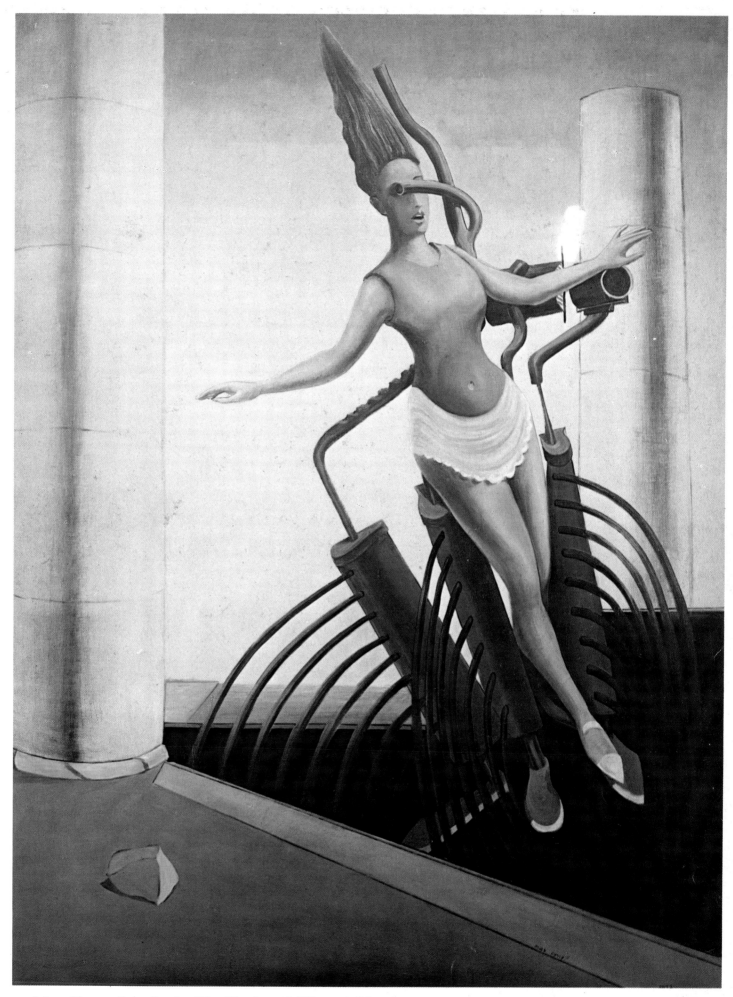

3. Max Ernst (b. 1891): *The Equivocal Woman* (also known as *The Teetering Woman*). 1923. Düsseldorf, Schloss Jägerhof

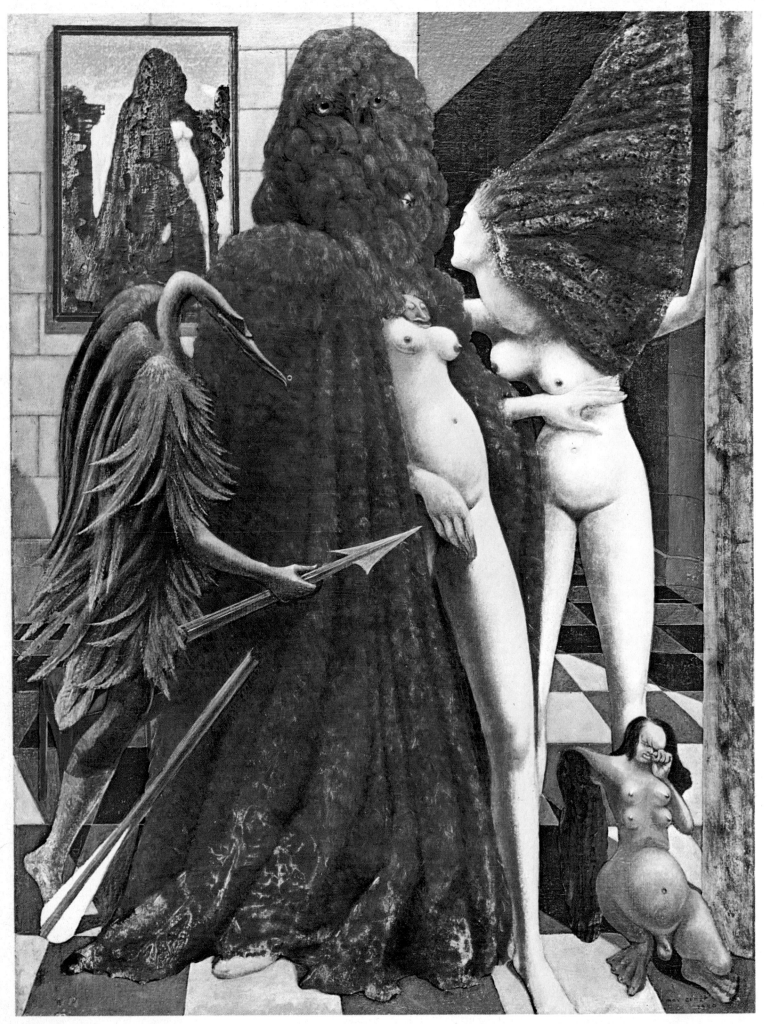

4. Max Ernst (b. 1891): *The Robing of the Bride*. 1939, Venice, Peggy Guggenheim Foundation

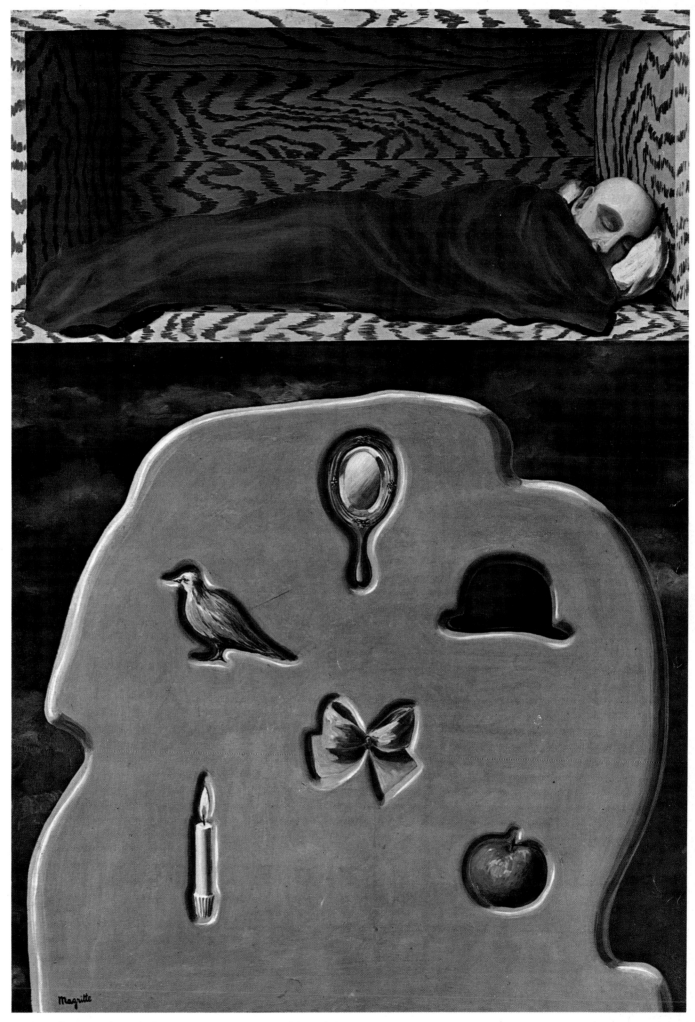

5. René Magritte (1898–1967): *The Reckless Sleeper*. 1927. London, Tate Gallery

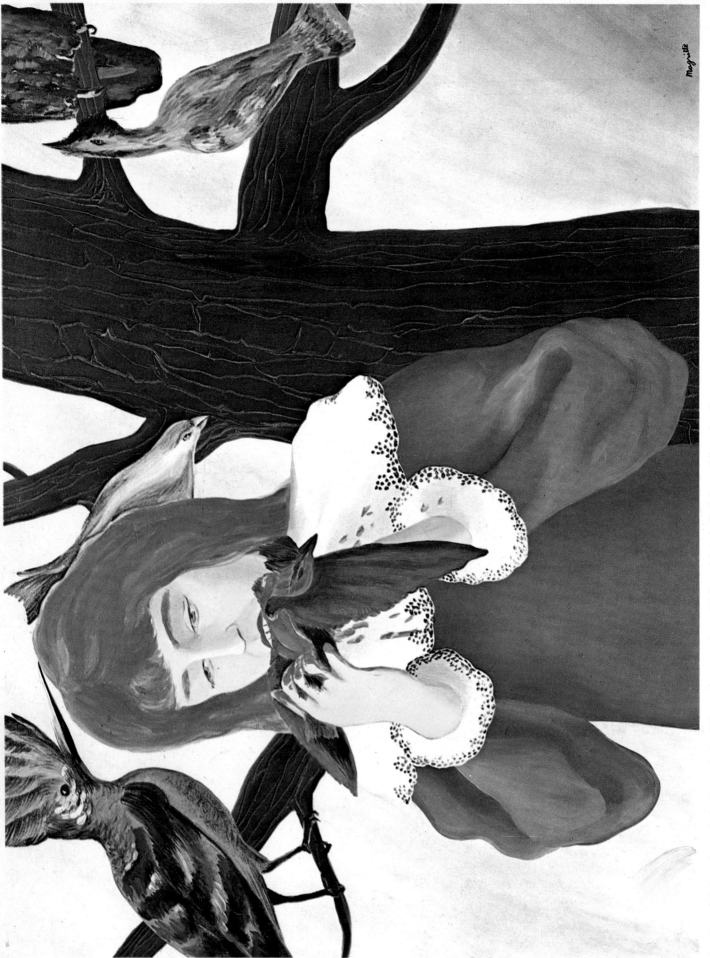

6. René Magritte (1898–1967): *Pleasure*. 1926–7. Düsseldorf, Schloss Jägerhof

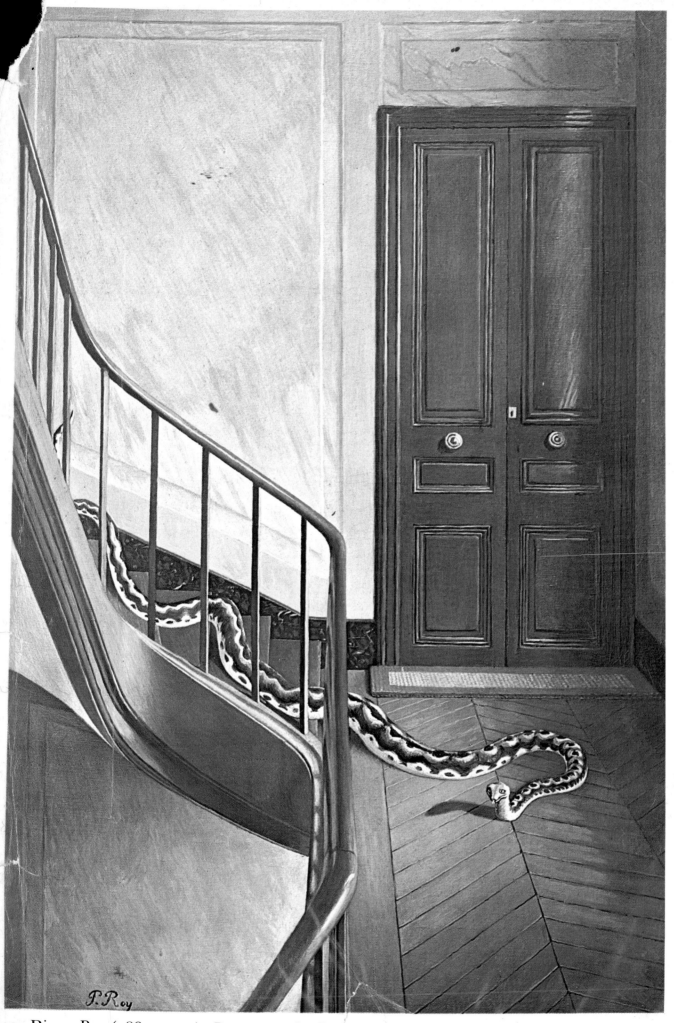

10. Pierre Roy (1880–1950): *Danger on the Stairs*. 1927–8. New York, Museum of Modern Art

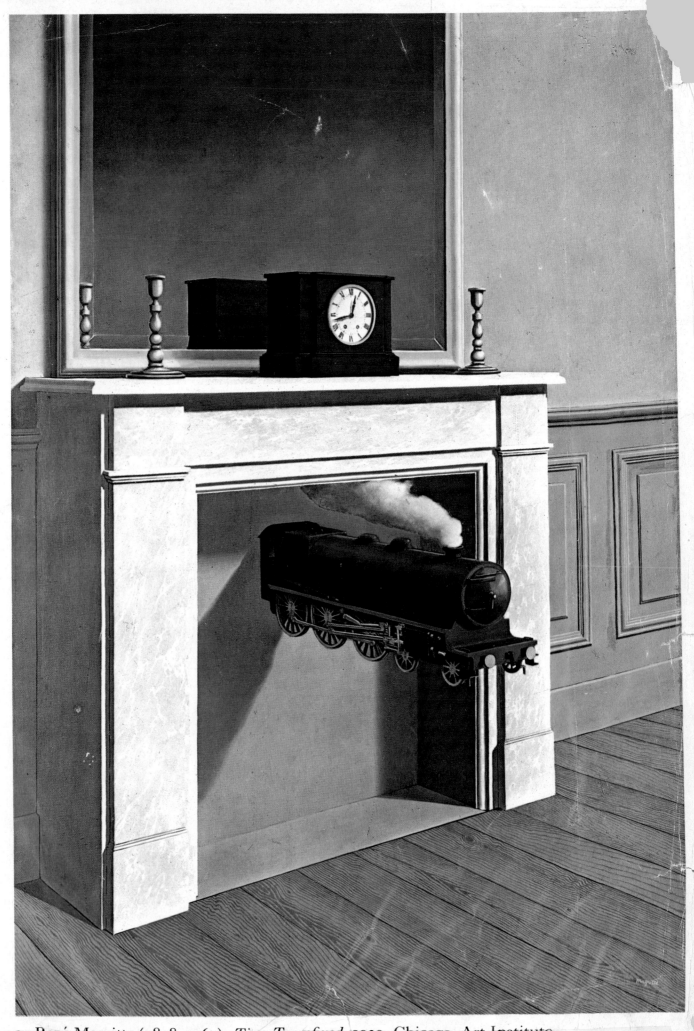

9. René Magritte (1898–1967): *Time Transfixed*. 1939. Chicago, Art Institute

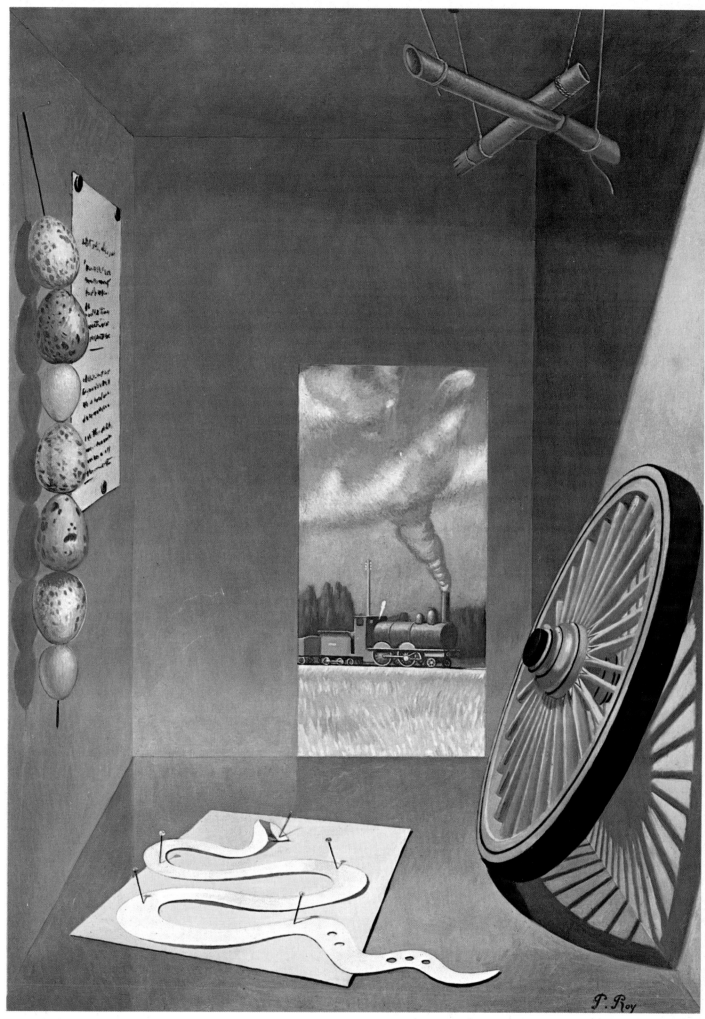

11. Pierre Roy (1880–1950): *A Naturalist's Study*. 1928. London, Tate Gallery

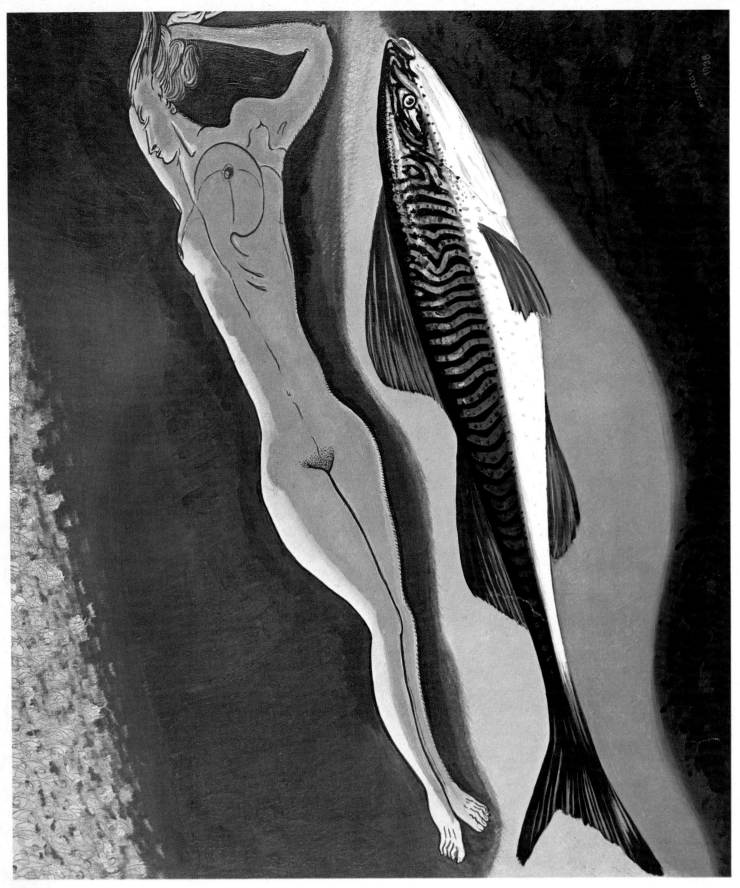

12. Man Ray (b. 1890): *Pisces*. 1938. London, Tate Gallery

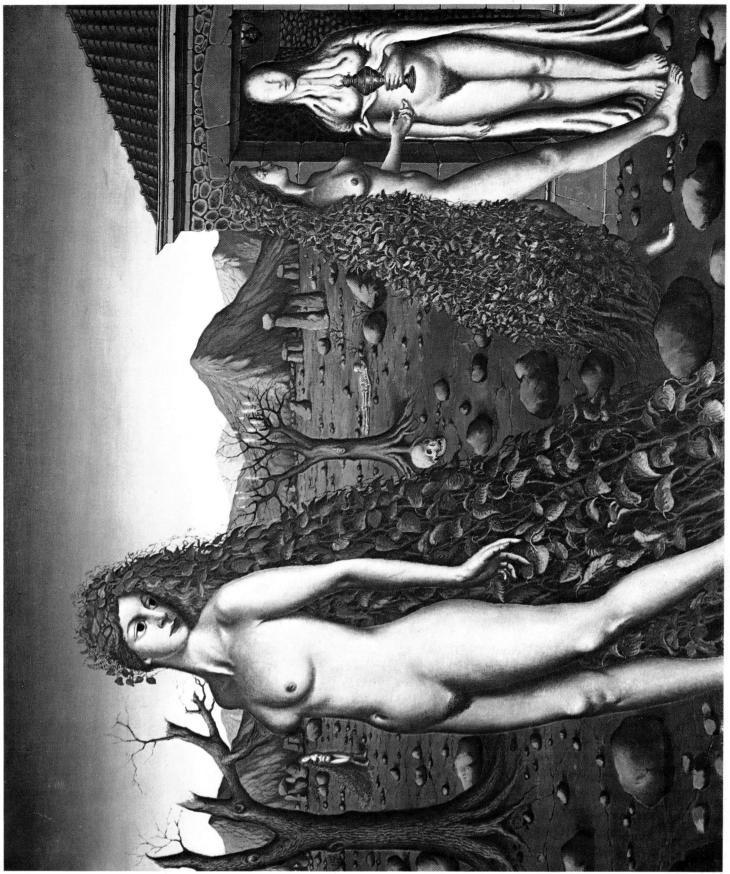

13. Paul Delvaux (b. 1897): *The Call of the Night*. 1937. London, Private Collection

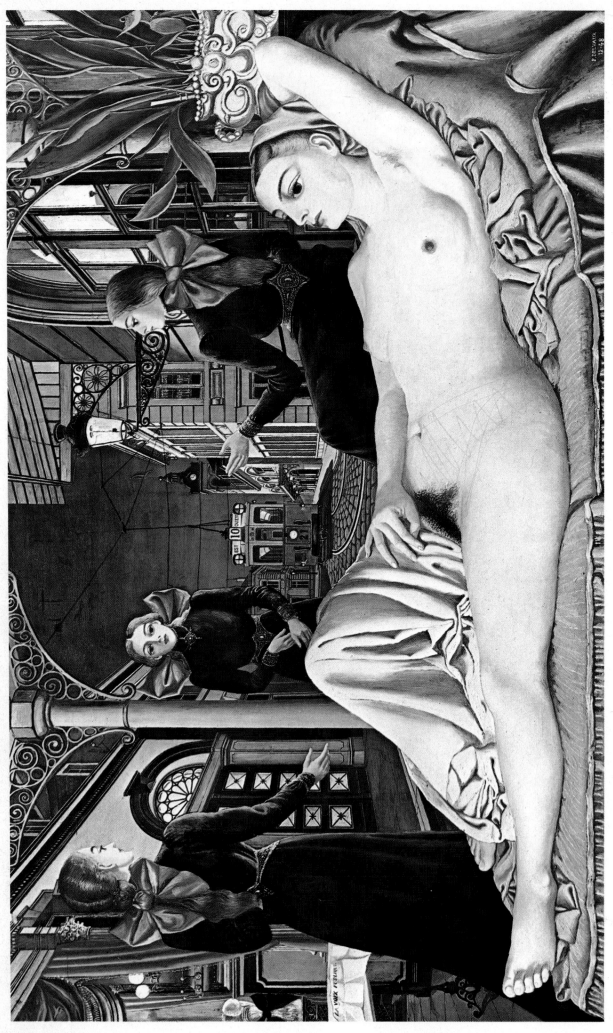

14. Paul Delvaux (b. 1897): *The Public Voice*. 1948. Brussels, Musées Royaux

15. Paul Delvaux (b. 1897): *The Night Train*. 1947. Tokyo, Ginza Nova

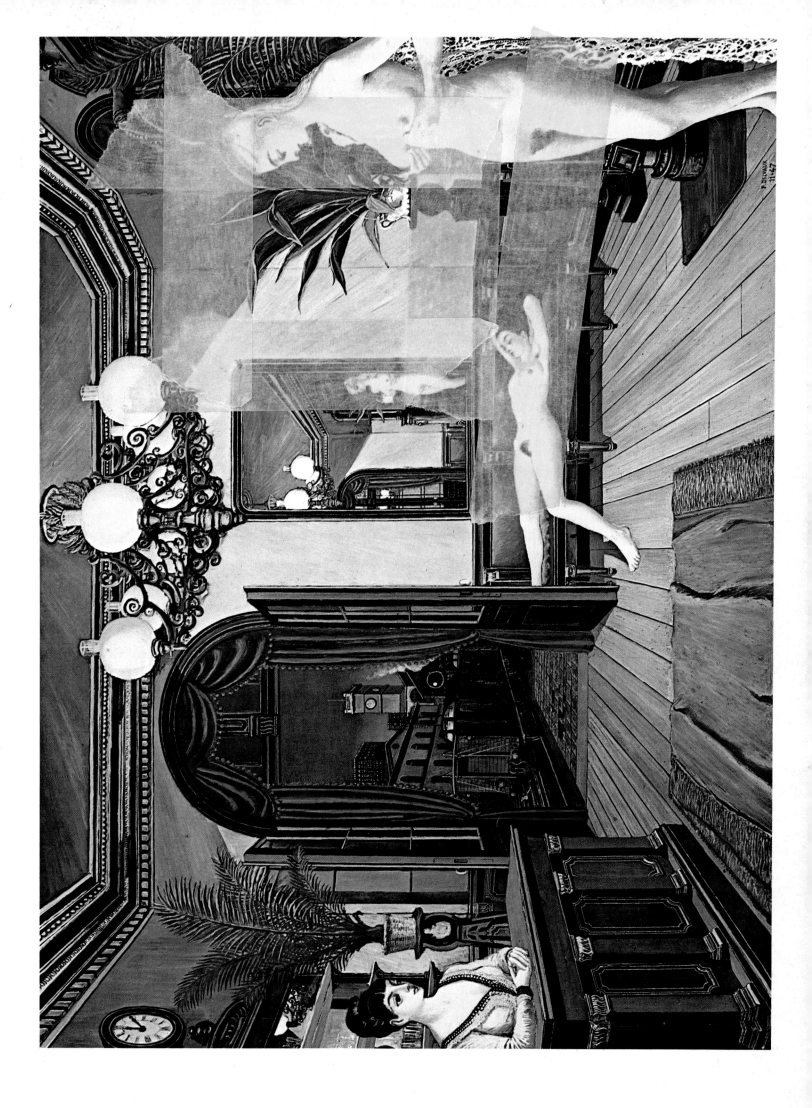

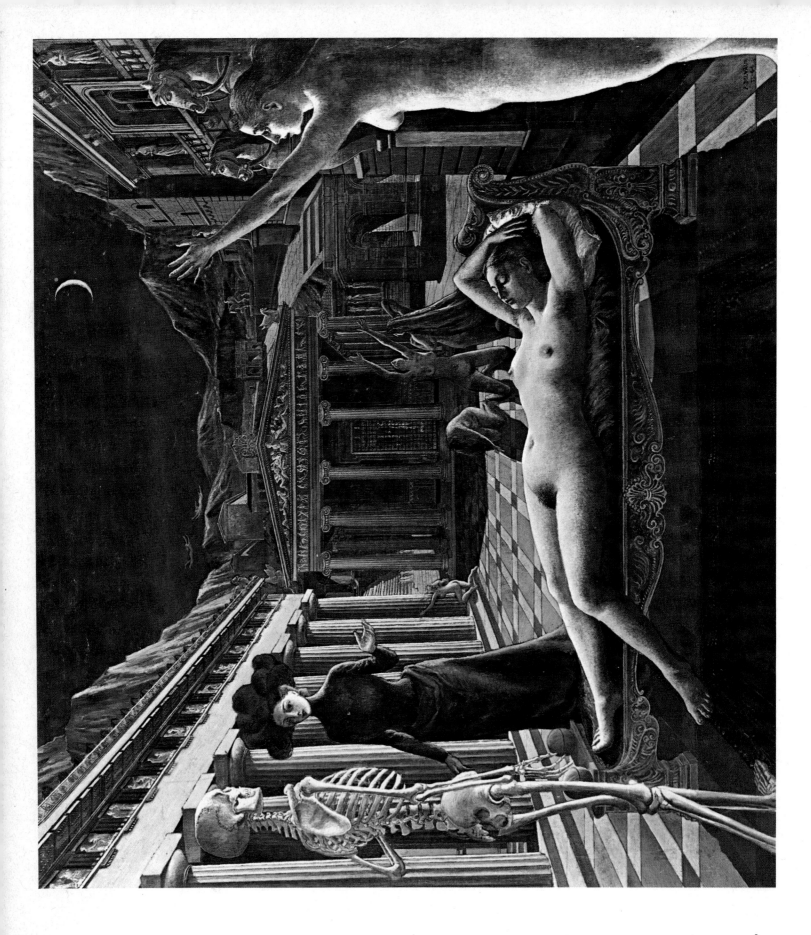

16. Paul Delvaux
(b. 1897):
Venus Asleep.
1944. London,
Tate Gallery

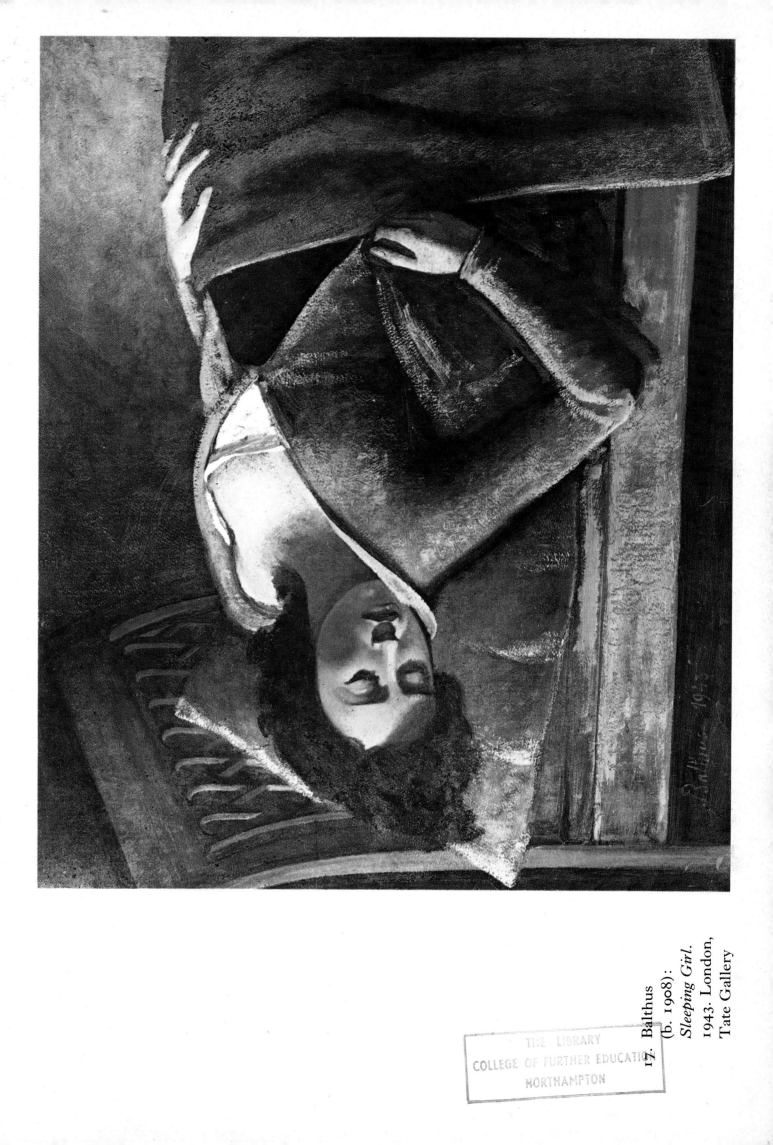

17. Balthus
(b. 1908):
Sleeping Girl.
1943. London,
Tate Gallery

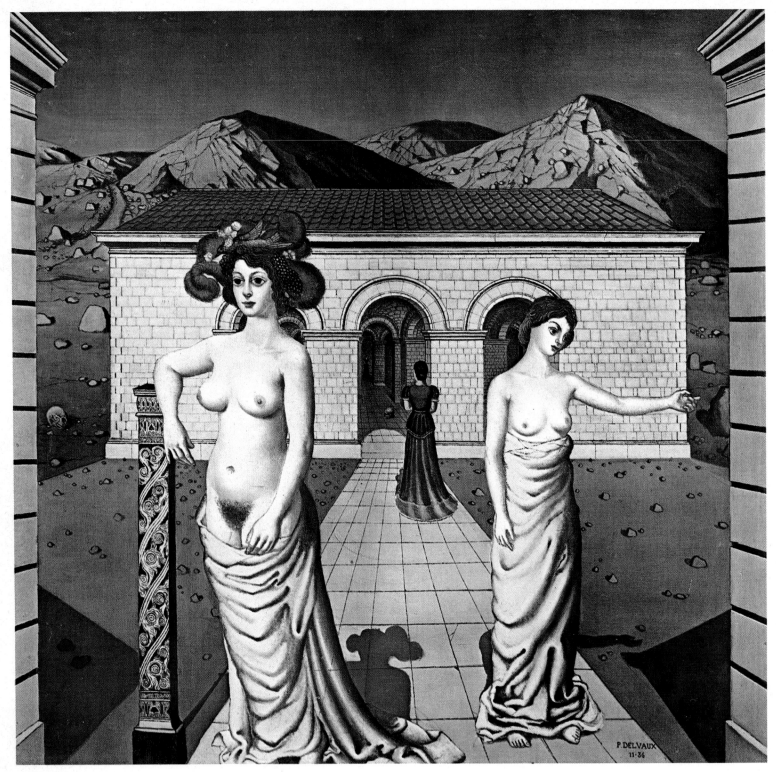

18. Paul Delvaux (b. 1897): *Les Belles de Nuit*. 1936. Sussex, E. F. W. James, Esq.

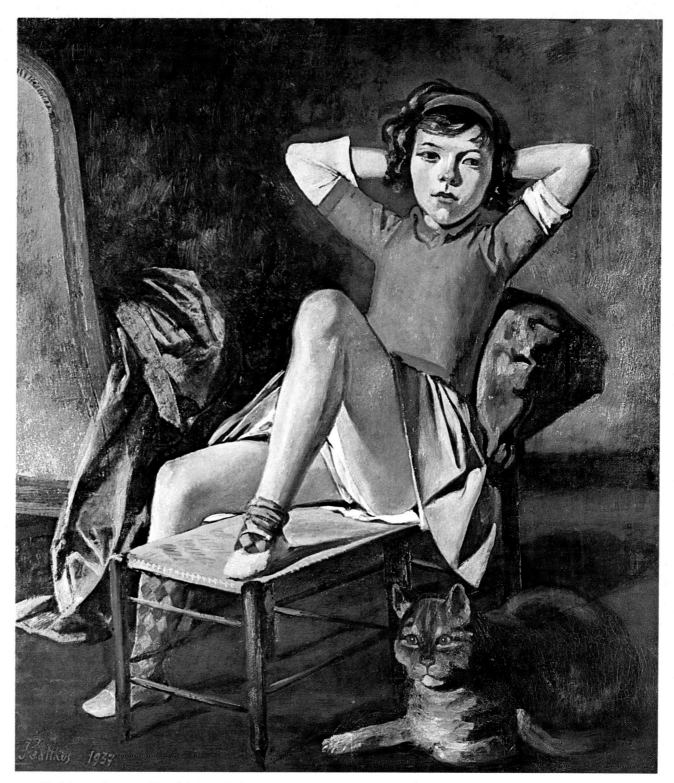

19. Balthus (b. 1908): *Girl and Cat*. 1937. Chicago, Mr and Mrs E. A. Bergman

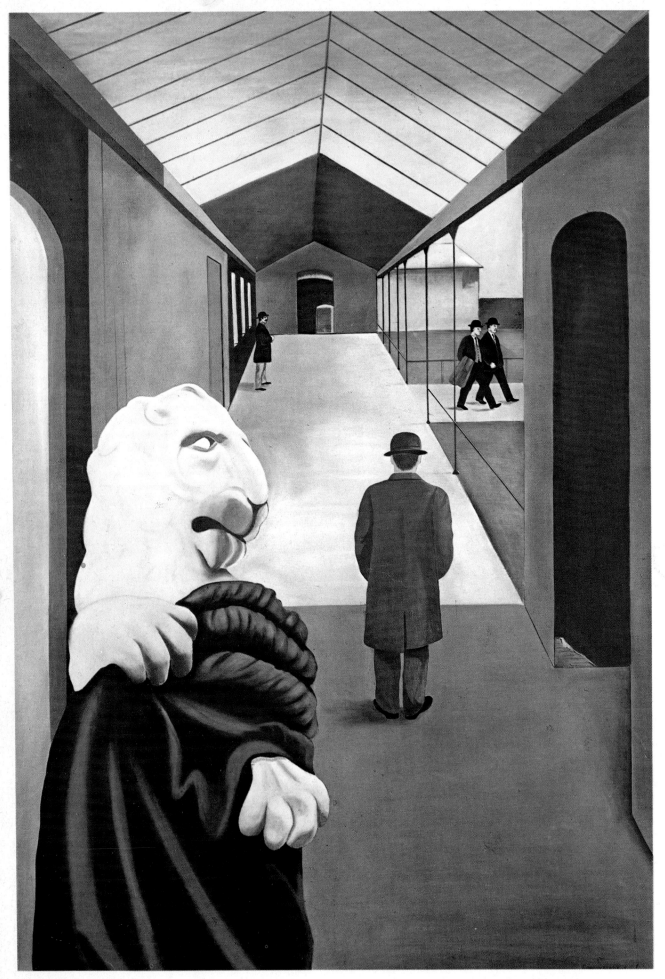

20. Conroy Maddox (b. 1912): *Passage de l'Opéra*. 1940. London, Hamet Fine Art

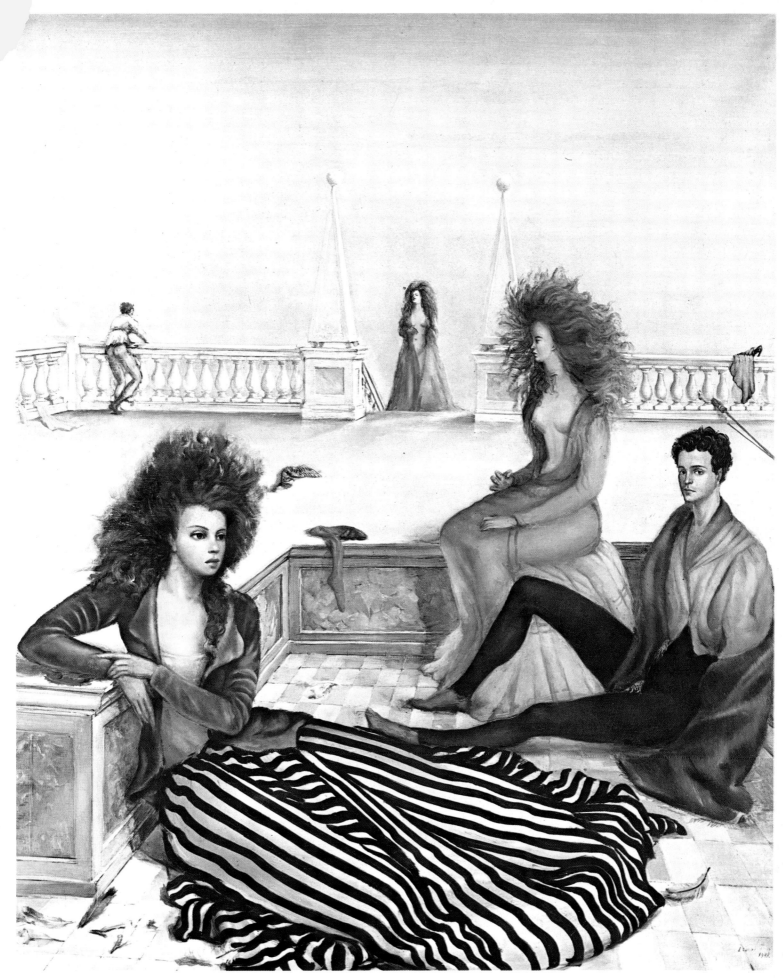

21. Leonor Fini (b. 1908): *Figures on a Terrace*. 1938. Sussex, Edward James Foundation

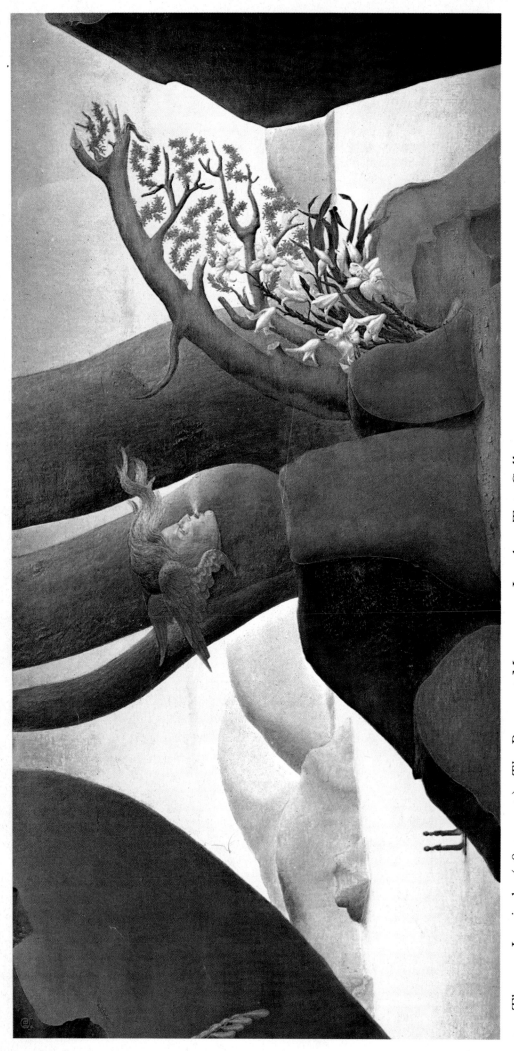

22. Thomas Lowinsky (1892–1947): *The Breeze at Morn.* 1930. London, Tate Gallery

23. Paul Nash (1889–1946): *Landscape from a Dream*. 1936–8. London, Tate Gallery

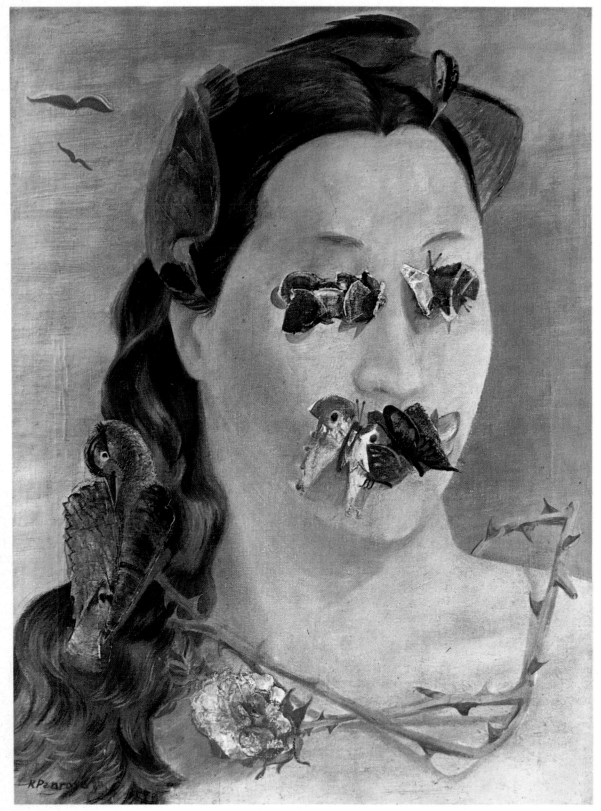

24. Roland Penrose (b. 1900): *Portrait of Valentine*. 1937. London, Private Collection

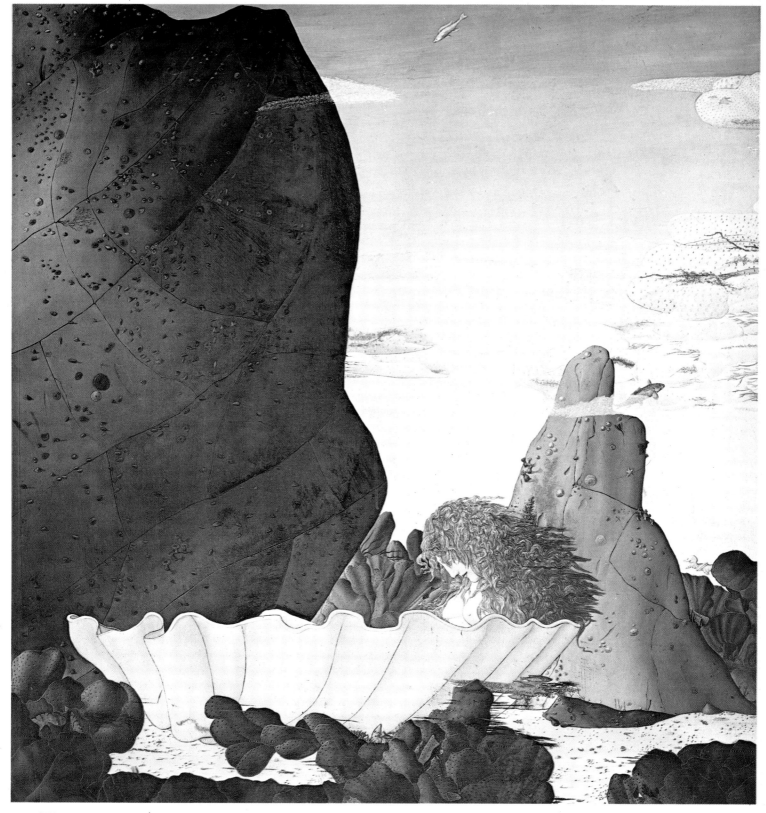

25. Thomas Lowinsky (1892–1947): *The Dawn of Venus.* 1922. London, Tate Gallery

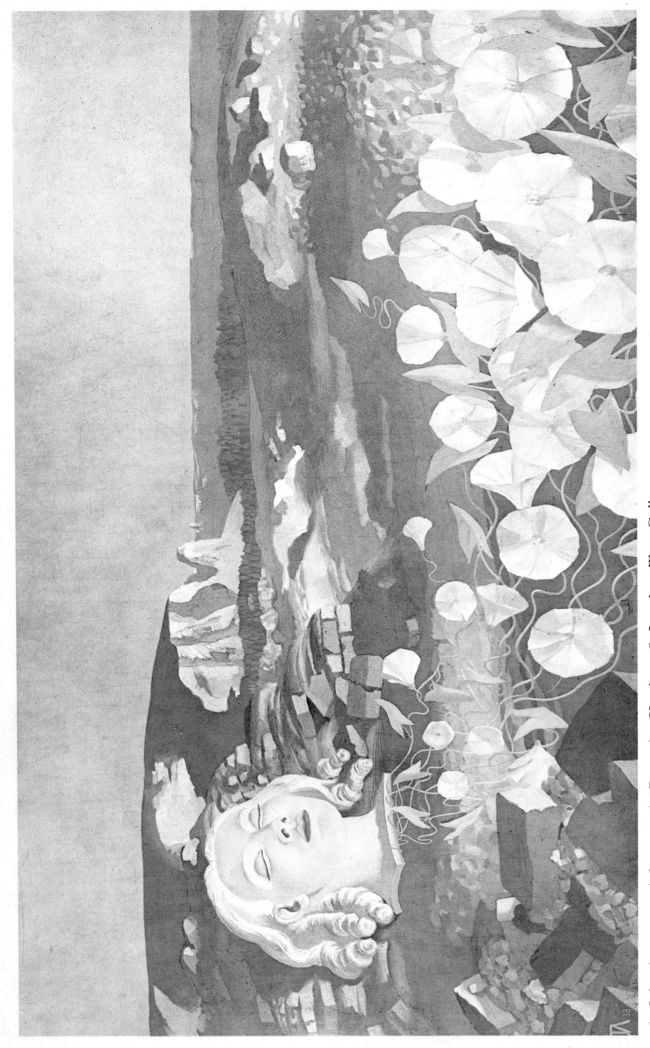

26. John Armstrong (1893–1973): *Dreaming Head*. 1938. London, Tate Gallery

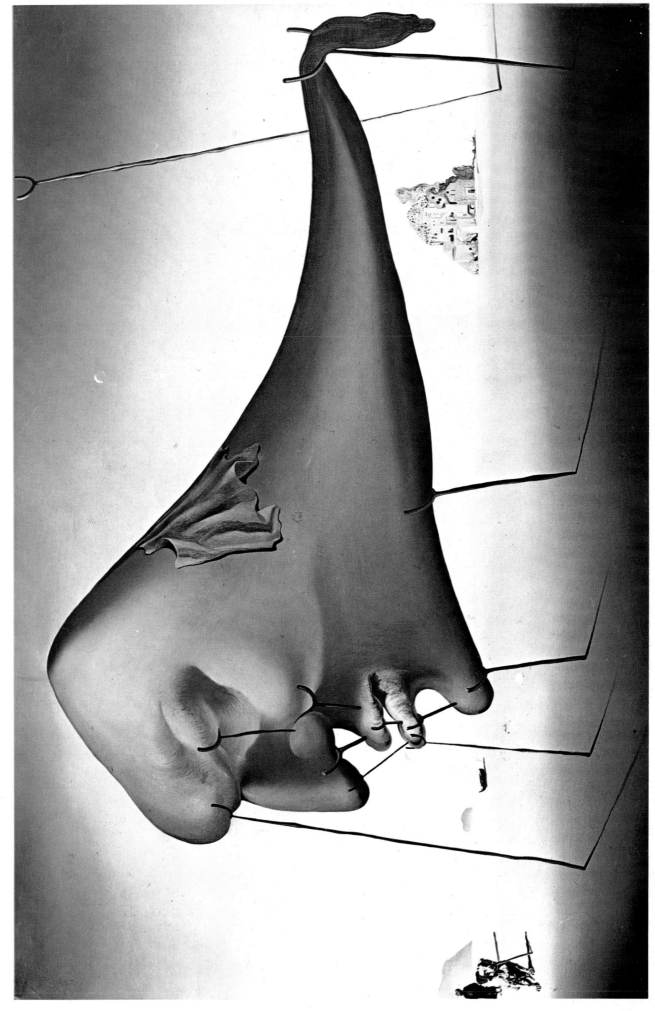

29. Salvador Dali (b. 1904): *Sleep*. 1937. USA, New Trebizond Foundation

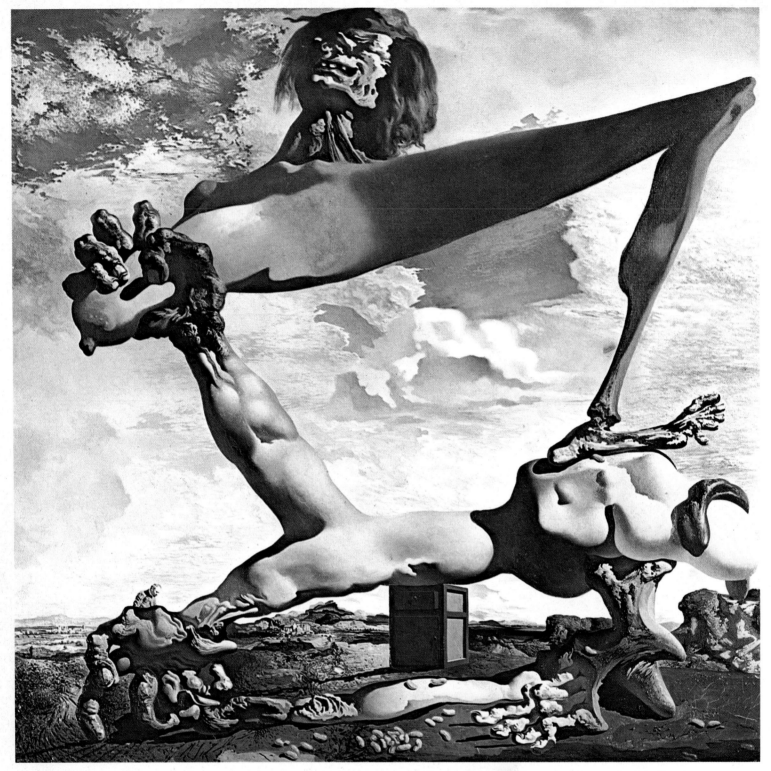

30. Salvador Dali (b. 1904): *Soft Construction with Boiled Beans: Premonition of Civil War*. 1936.
Philadelphia, Museum of Art. Louise & Walter Arensberg Collection

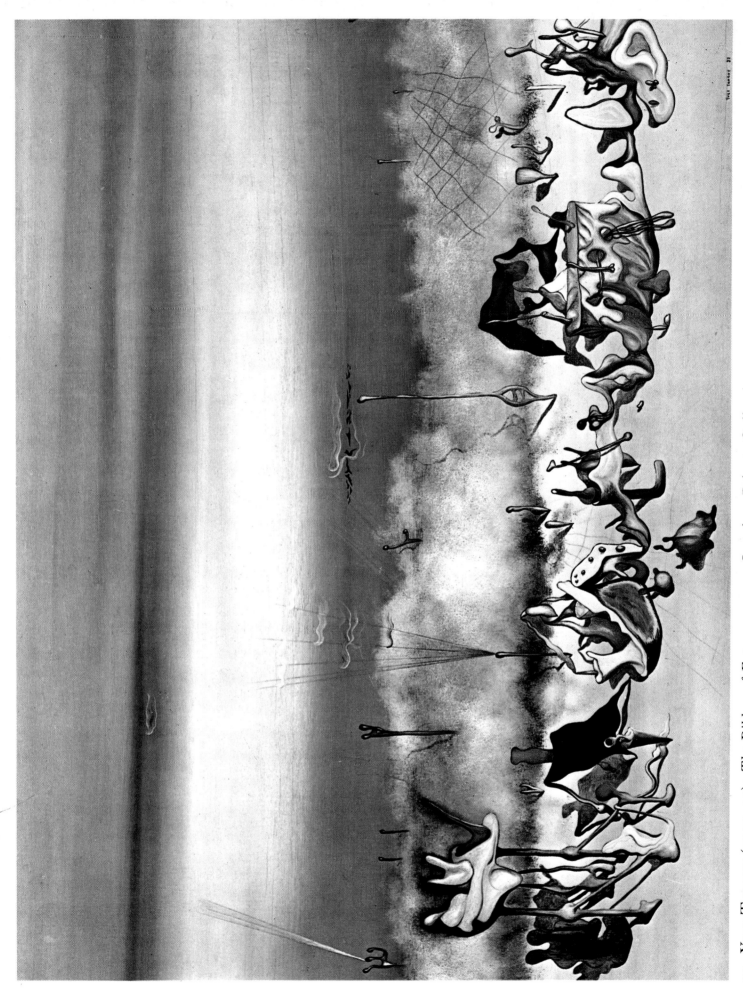

33. Yves Tanguy (1900–55): *The Ribbon of Extremes*. 1932. London, Private Collection

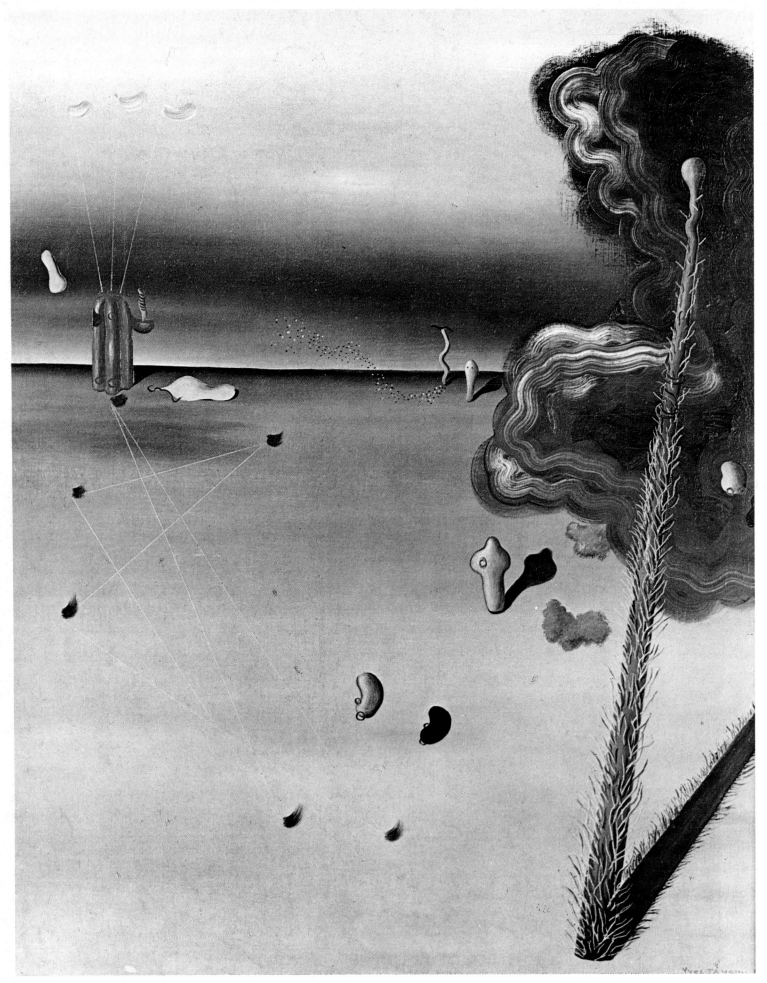

34. Yves Tanguy (1900–55): *Mama, Papa is Wounded!* 1927. New York, Museum of Modern Art

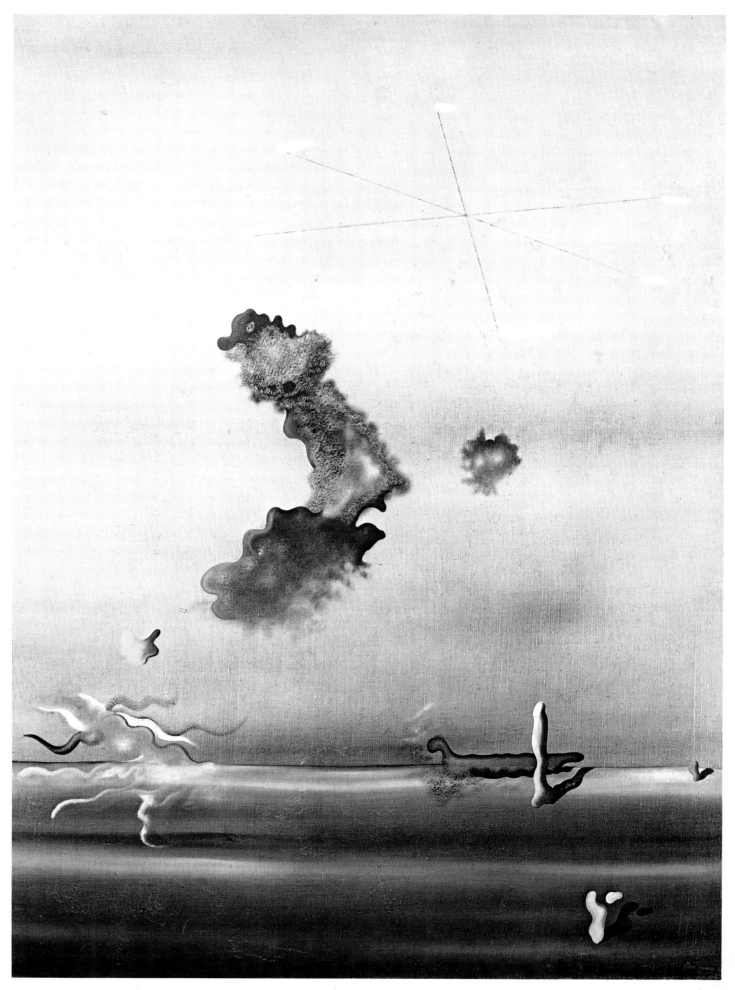

35. Yves Tanguy (1900–55): *Outside*. 1929. London, Private Collection

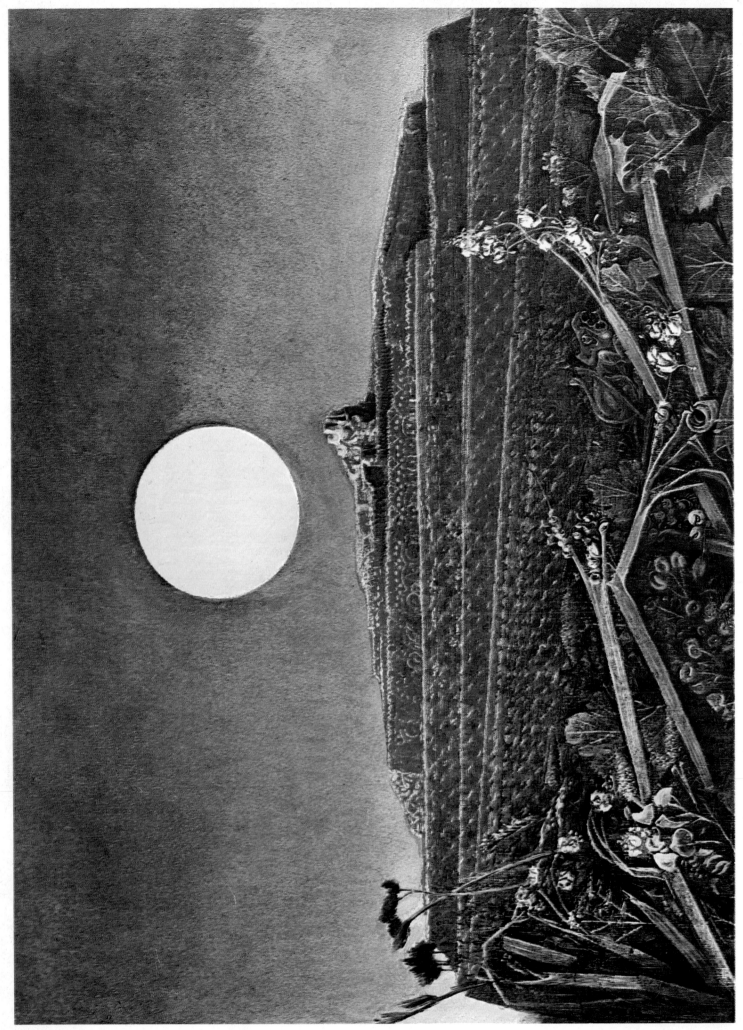

36. Max Ernst (b. 1891): *The Whole City*. 1935. Zurich, Kunsthaus

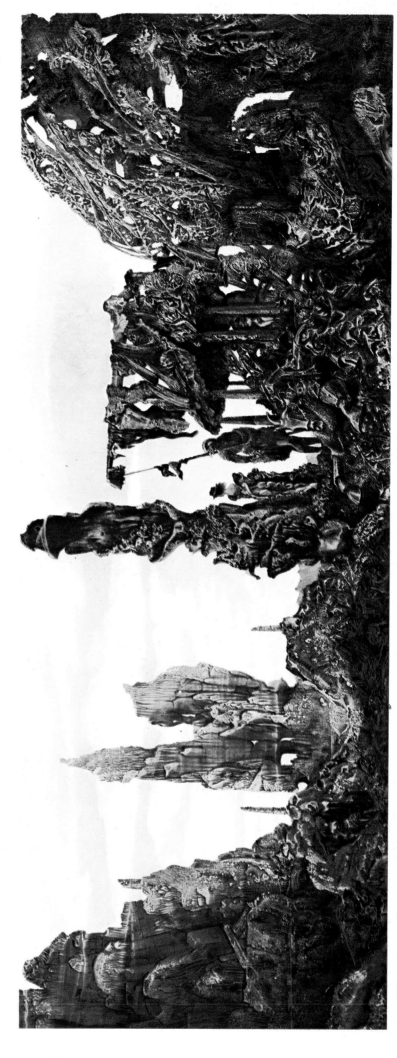

37. Max Ernst (b. 1891): *Europe After the Rain*. 1940–2. Hartford, Conn., Wadsworth Atheneum

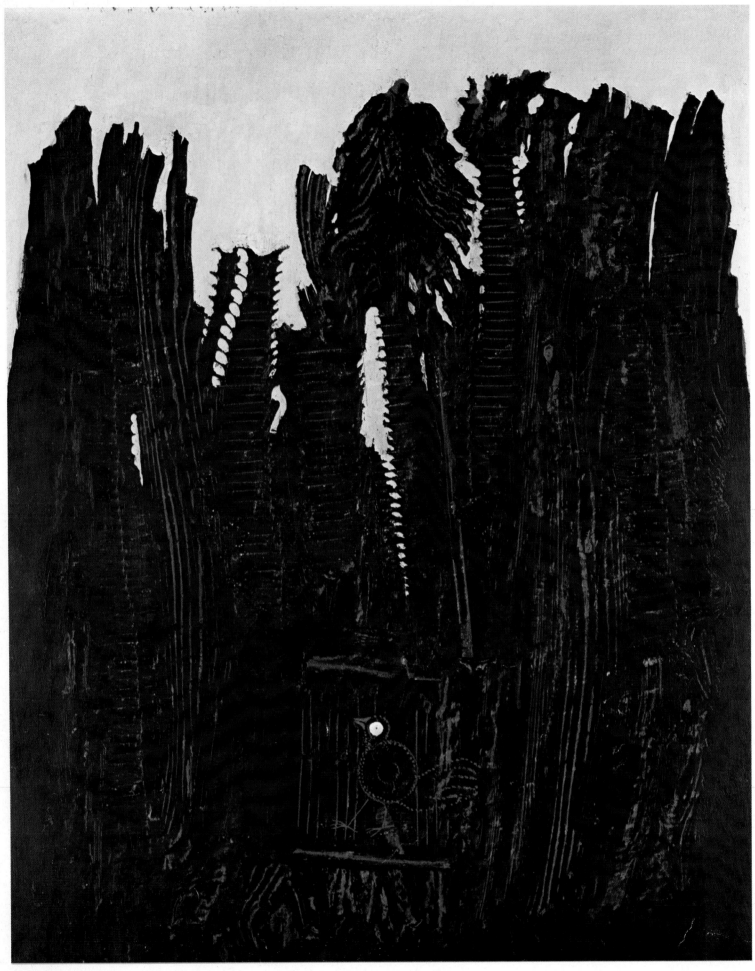

38. Max Ernst (b. 1891): *The Forest.* 1927. London, Tate Gallery

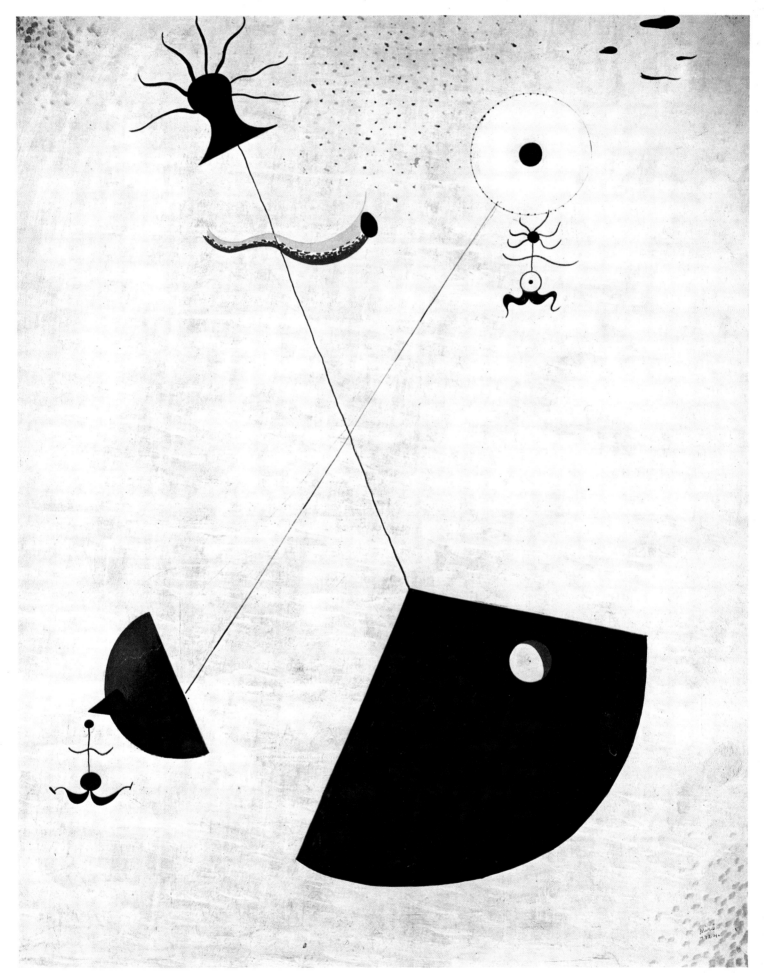

39. Joan Miró (b. 1893): *Maternity*. 1924. London, Private Collection

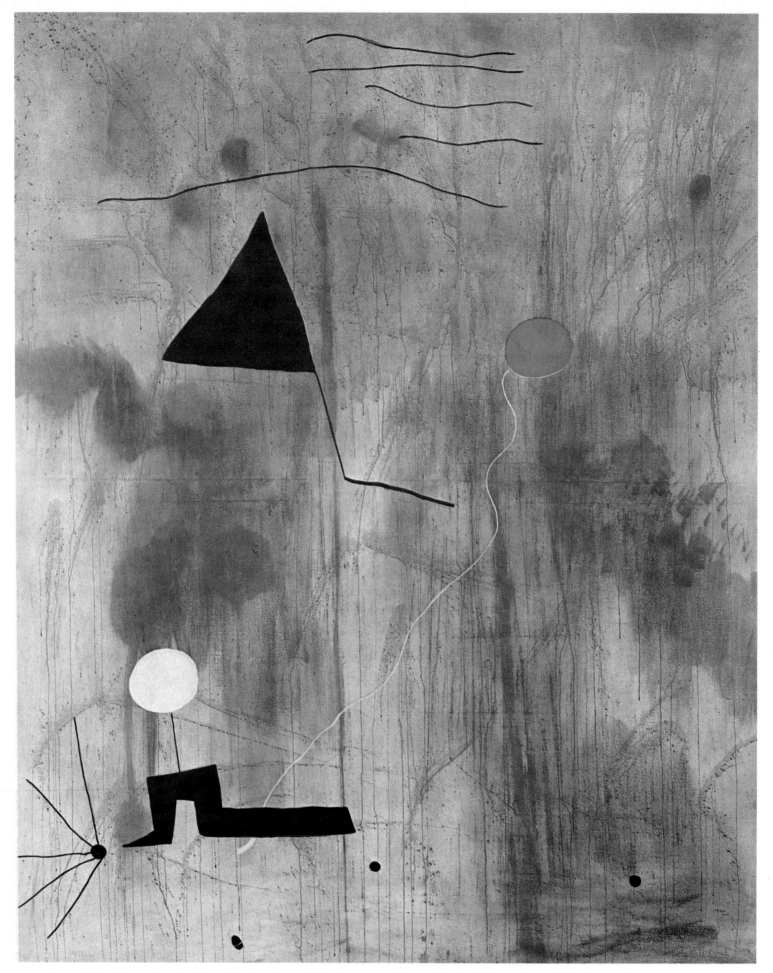

40. Joan Miró (b. 1893): *The Birth of the World*. 1925. New York, Museum of Modern Art

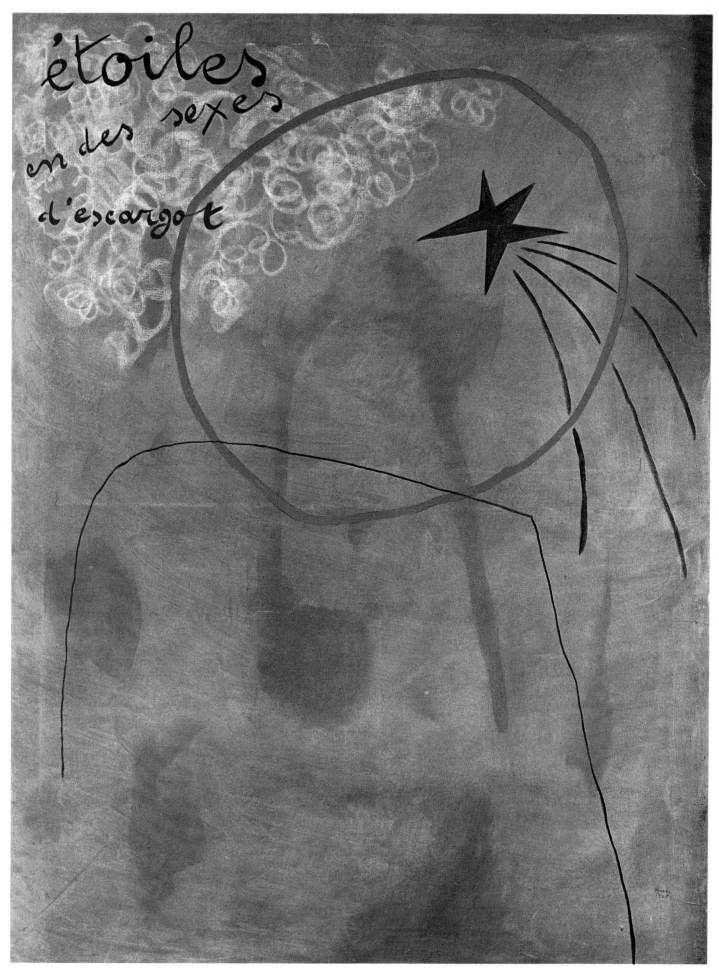

41. Joan Miró (b. 1893): *Stars in Snails' Sexes*. 1925. Düsseldorf, Schloss Jägerhof

Photo

ceci est la couleur de mes rêves.

42. Joan Miró (b. 1893): *Photo: This is the Colour of My Dreams.* 1925. New York, Private Collection

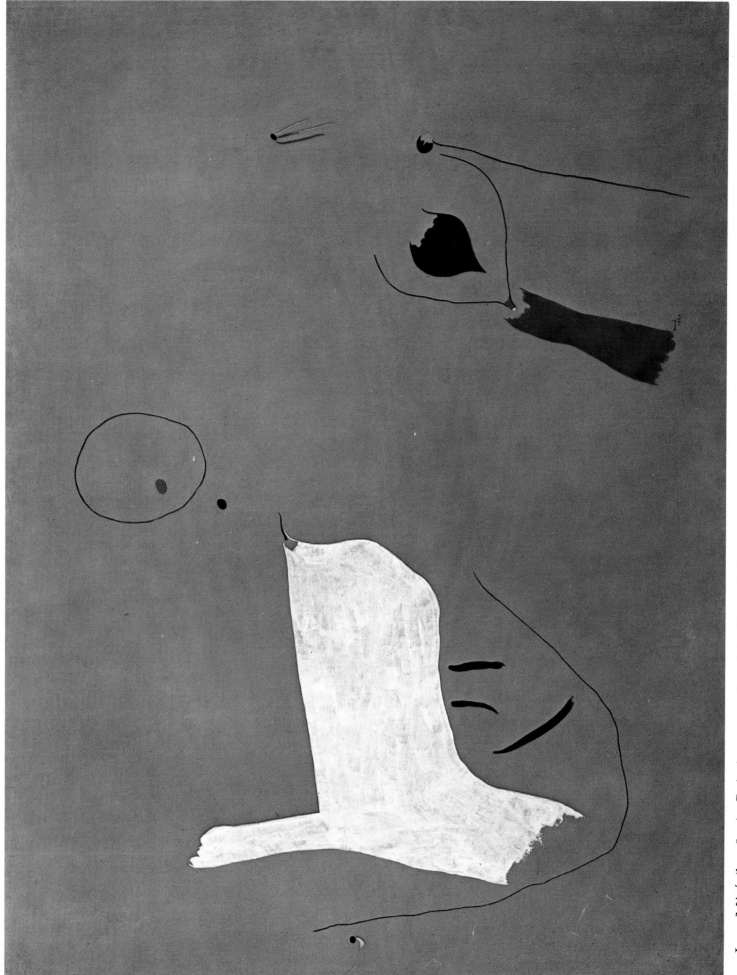

43. Joan Miró (b. 1893): *Painting*. 1927. London, Tate Gallery

44. André Masson (b. 1896): *Battle of Fishes*. 1927. New York, Museum of Modern Art

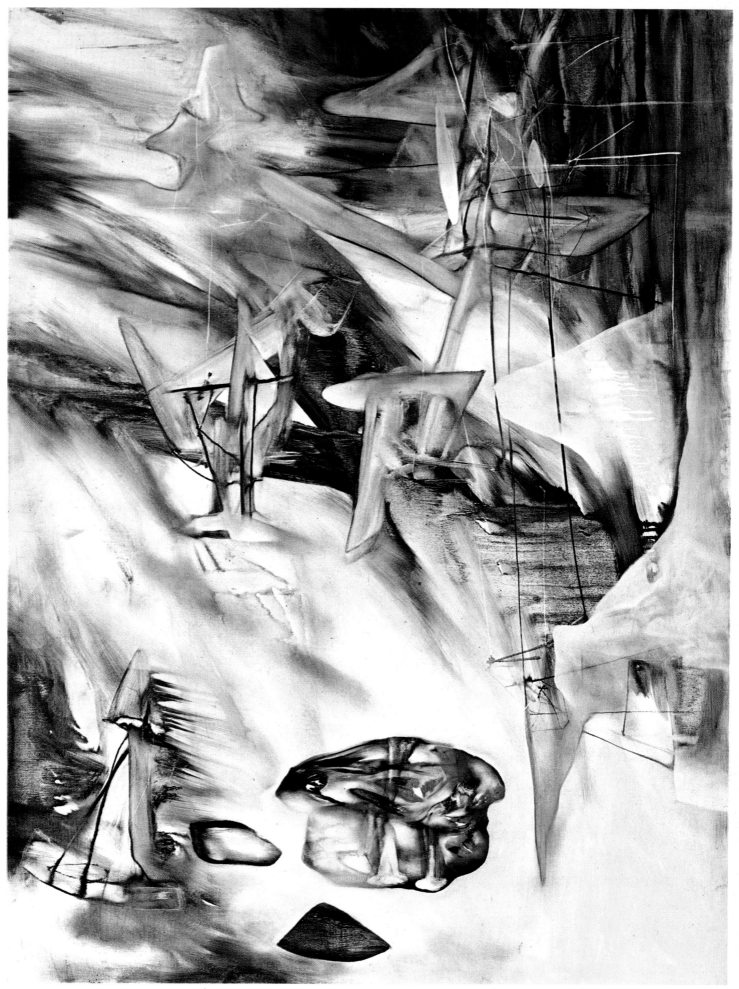

45. Roberto Matta (b. 1912): *The Hanged Man*. 1942. Basel, Galerie Beyeler

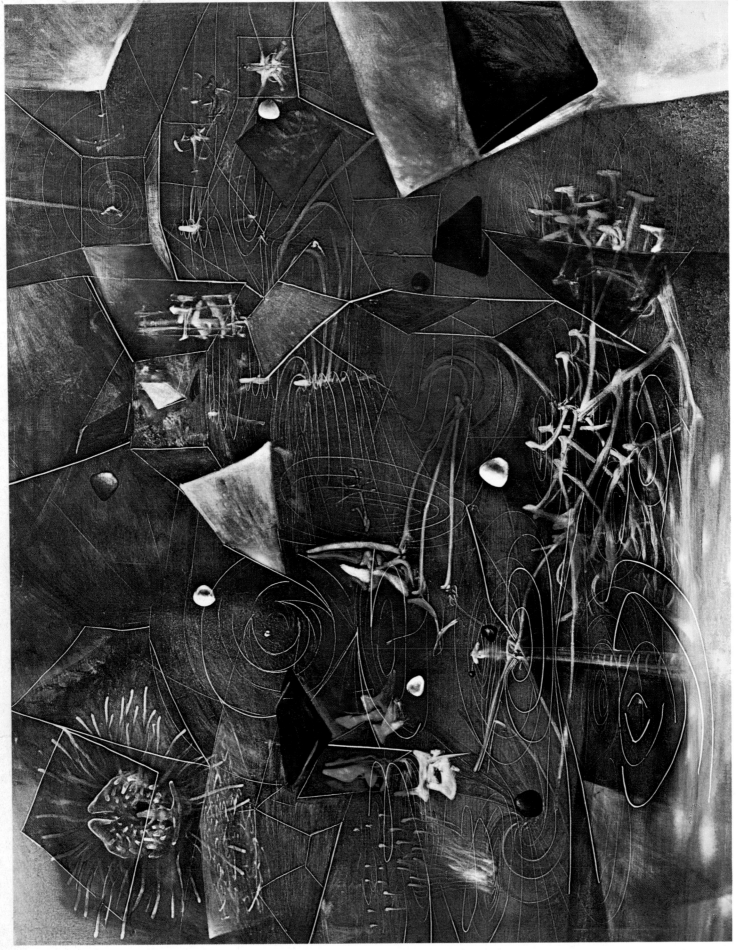